MW00807746

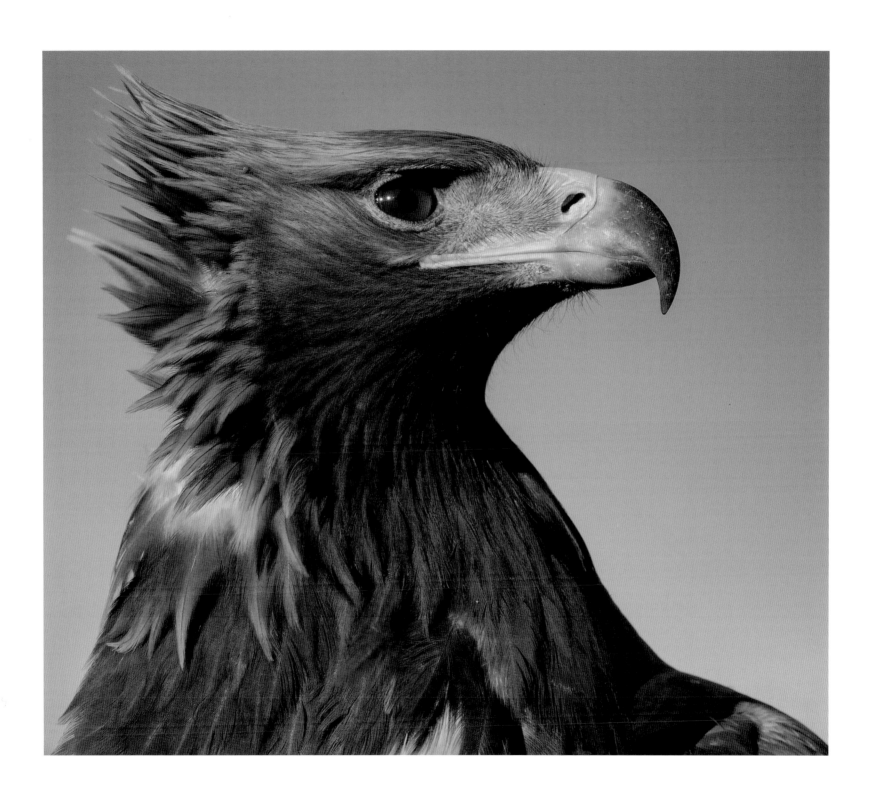

Palani Mohan

Hunting with Eagles
In the Realm of the Mongolian Kazakhs

MERRELL
LONDON · NEW YORK

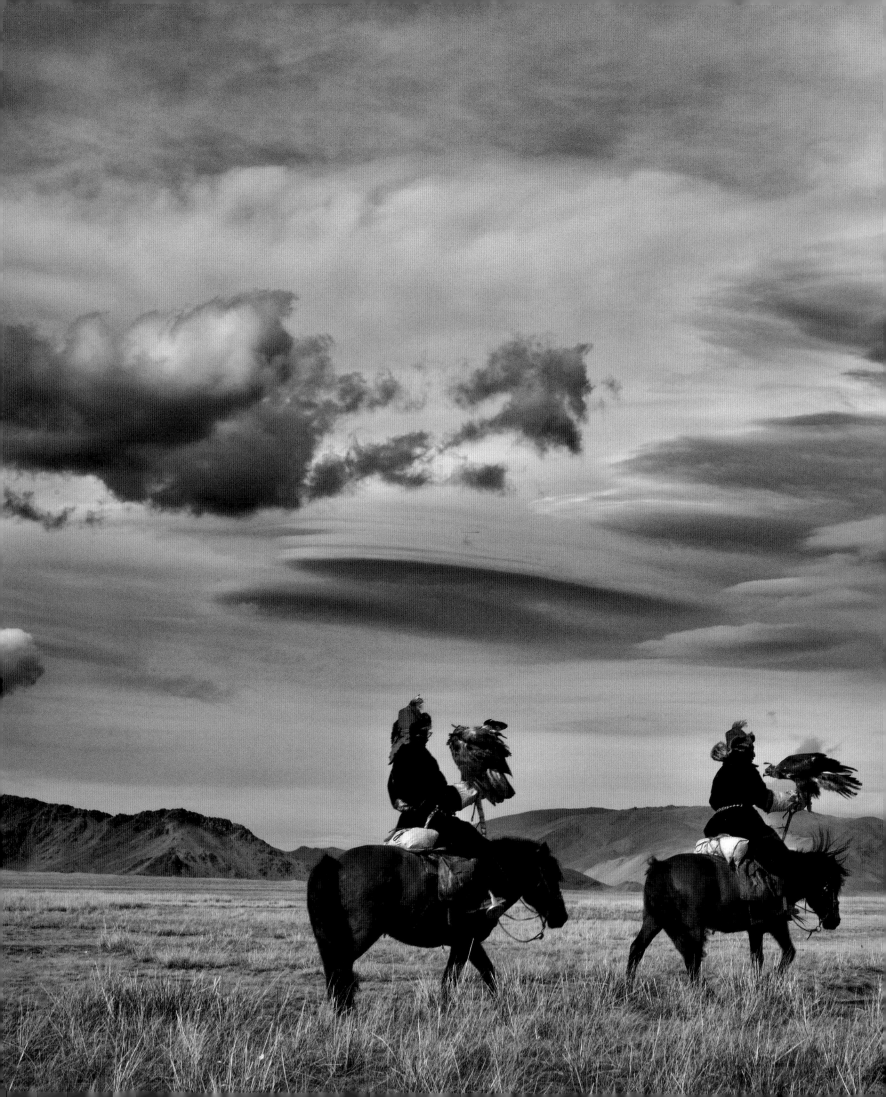

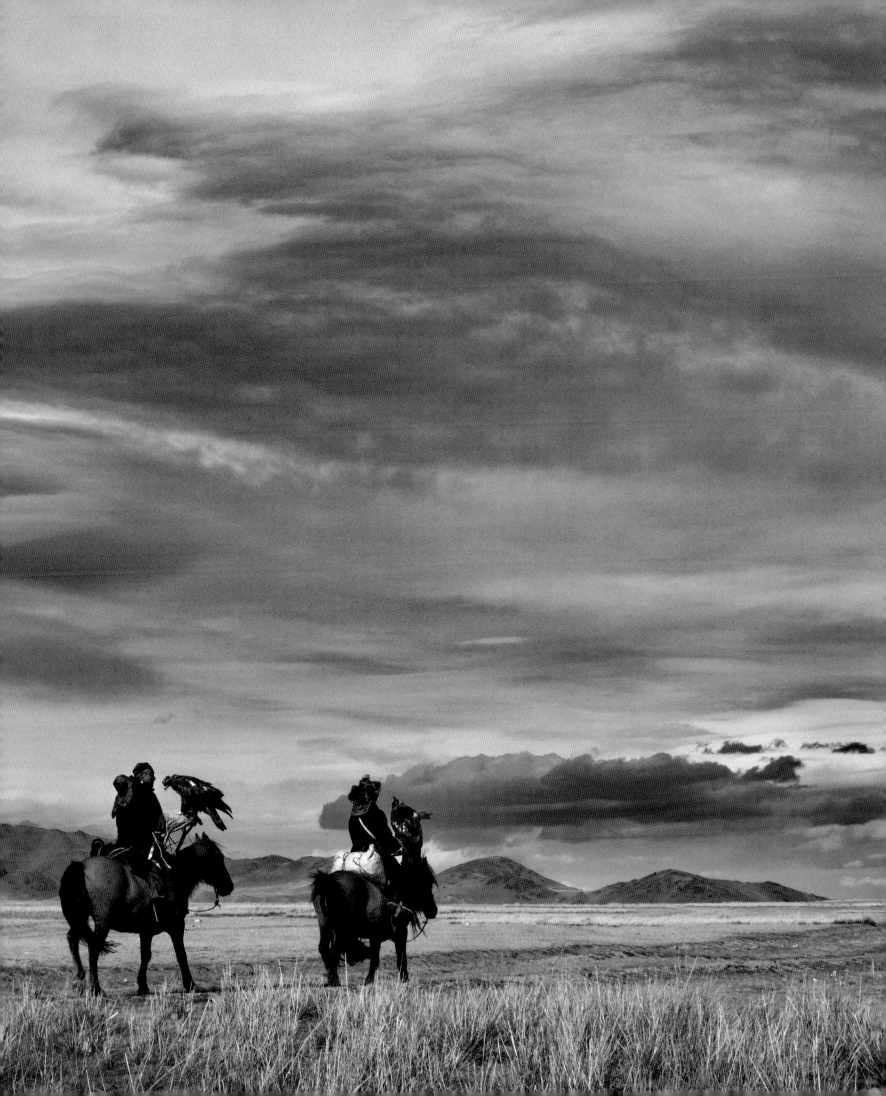

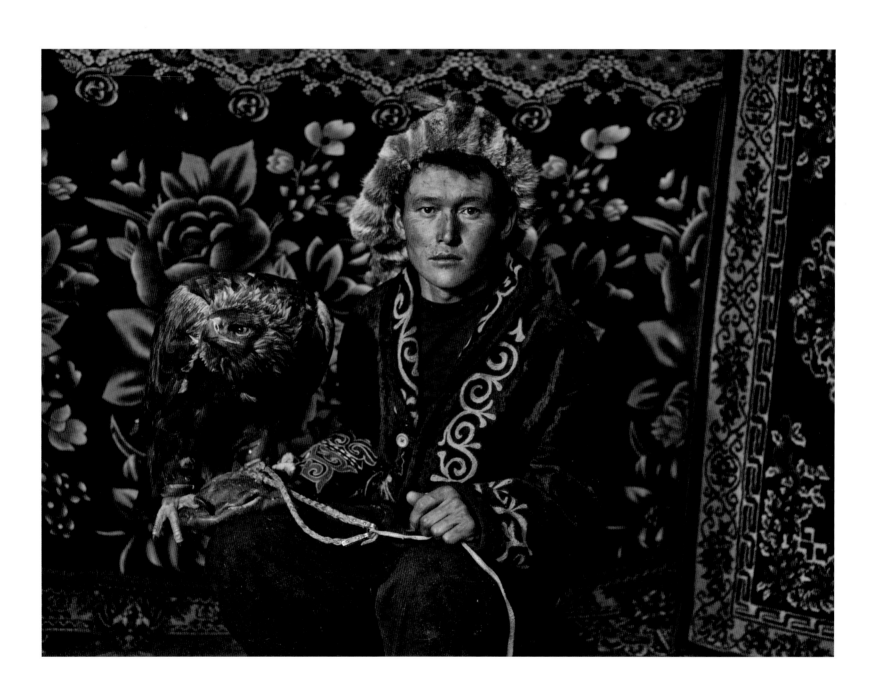

CONTENTS

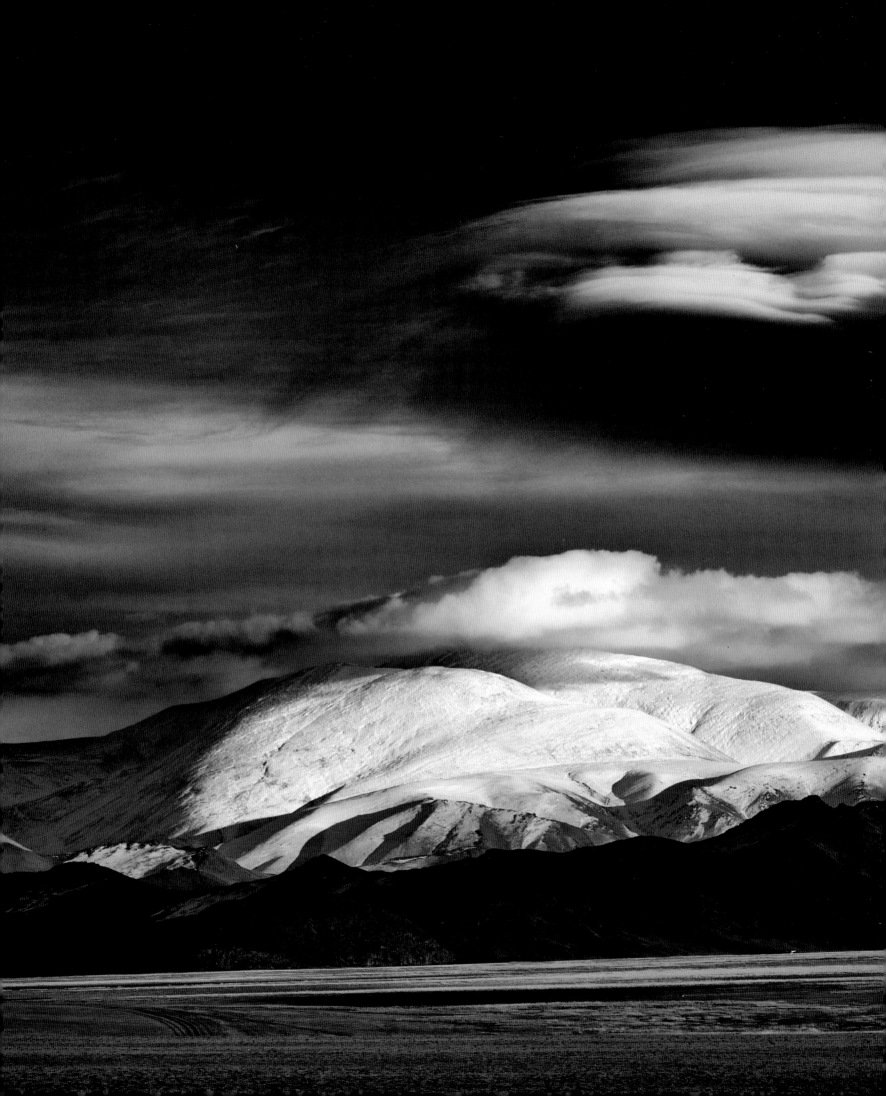

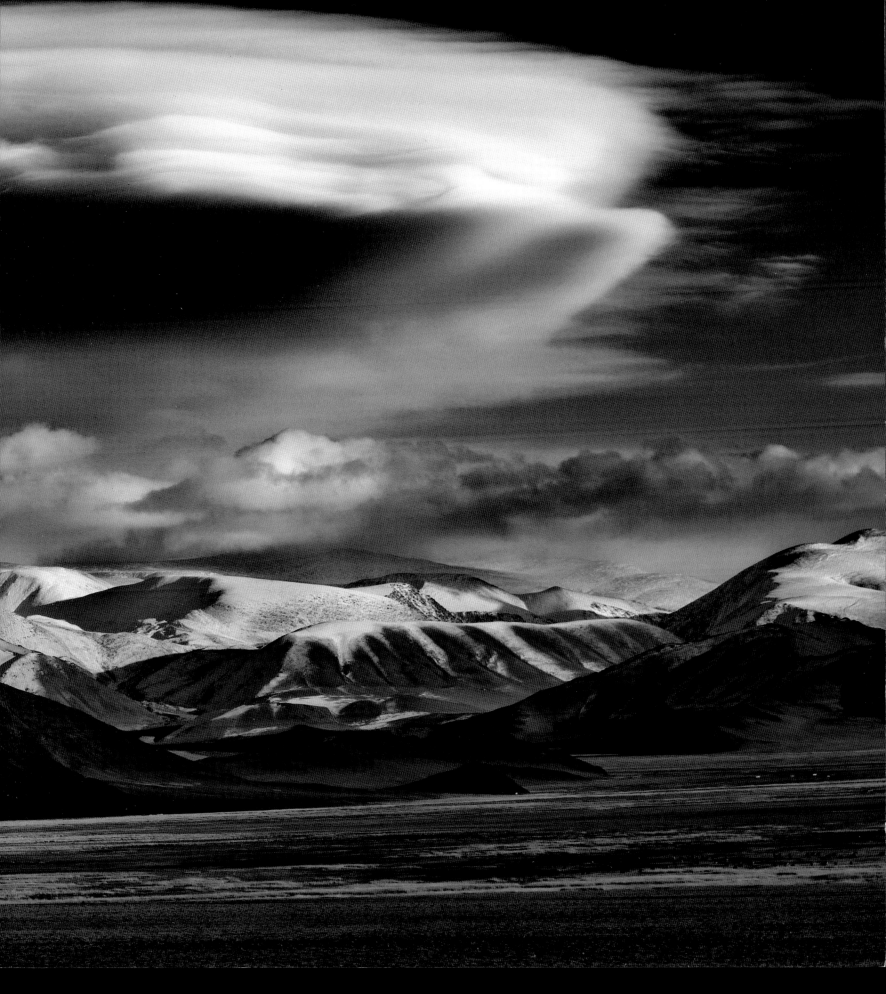

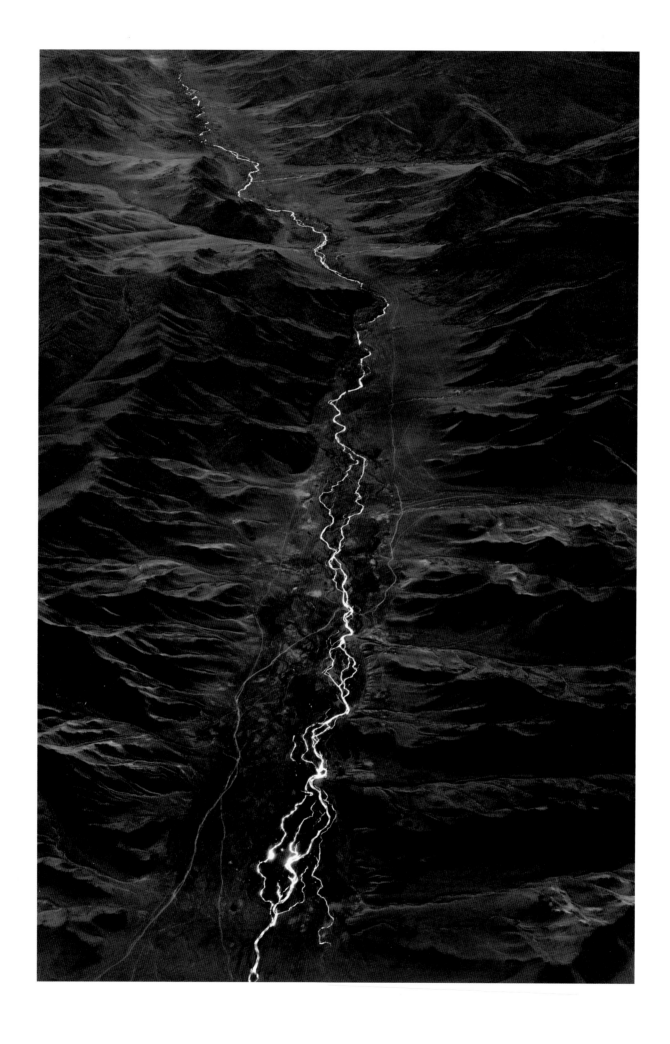

Foreword

Palani Mohan first made contact in 2013, sending me a selection of photographs from his numerous trips to the Altai Mountains in the far western reaches of Mongolia. It is a vast and unforgiving landscape, where temperatures routinely drop to -40°C (-40°F) in winter, and where the skies are filled with forbidding lenticular cloud formations. During the long winters the *burkitshi* (eagle-hunters) leave their homes with horse and eagle, and head into the mountains to hunt for several days at a time. Palani's photographs struck me forcefully as conveying not only the hard beauty of this wild and seemingly empty terrain, but also, more significantly, the intense relationship that the hunter forges with his eagle. It is this bond of mutual respect and trust that defines the life of the *burkitshi* and gives it profound meaning.

It is rare to come across photographs of such power; rarer still for one photographer to be able to capture the stark beauty of such an immense landscape (consider, for example, the photograph on the opposite page), as well as the interaction between people and, in this book, between man and eagle. Yet Palani's deft touch with the camera and his determination to photograph in black and white combine to make *Hunting with Eagles* a true homage to the noble *burkitshi* and their extraordinary golden eagles.

Hugh Merrell,
London

Sunlight reflects off a frozen river in far northwestern Mongolia. The flight from the capital, Ulan Bator, to the remote town of Ölgii affords some spectacular views.

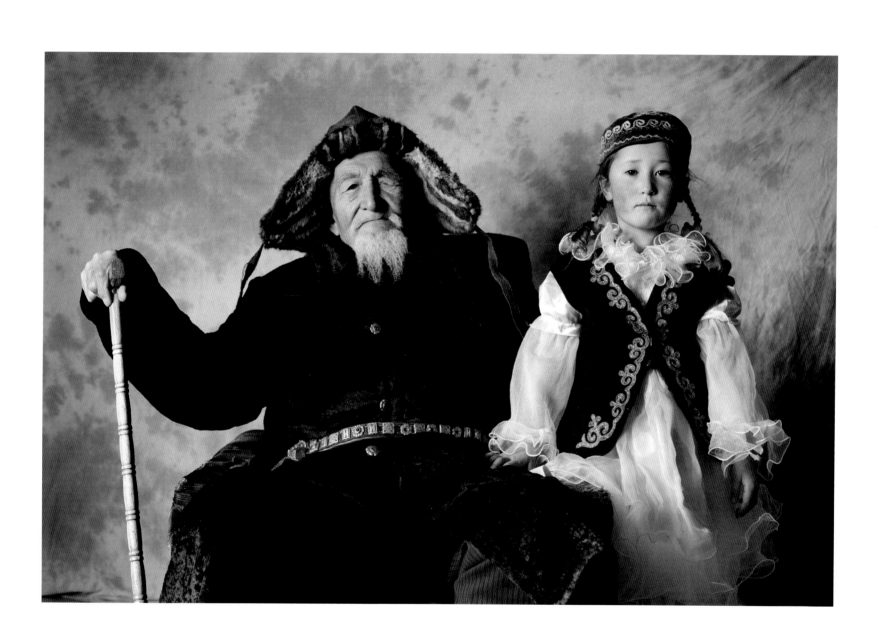

Introduction

Orazkhan Shuinshi was sitting in a weathered armchair in his *ger*, bathed in soft light from a window, when I first met him. A tall man with broad shoulders and hands like sandpaper, he was sipping yak's milk tea. It was December 2012. Winter had well and truly set in, and during the night the howling cold winds from the north had brought fresh snow to his valley near the Altai National Park in far western Mongolia, close to the borders with China and Russia.

Orazkhan was known as the oldest and wisest of the men who hunt with eagles – a living legend of sorts. He had gone blind in one eye and his hearing, once keen, was poor. He hardly ate anymore, and he missed his wife, who had died a decade previously. Over the course of the next few years, as I kept returning to that part of the world, I always made a point of visiting Orazkhan. We would drink tea together and talk about eagles and the changes he had seen in his ninety-plus years. I had many questions for him, and he would often ask me to stop talking and instead eat more of the meat and cheese on the table so I could stay warm. He was curious as to why I would leave my family year after year and return to the cold to ask more of these questions. He saw me as somewhat eccentric, but always indulged my enquiries and gave me his time. I told him I had an important job to do, to document the *burkitshi* – as the men who hunt with eagles are known in Kazakh – before they disappear, and that I needed his help.

HISTORY OF A HARD LAND

The ethnic Kazakhs number around 100,000 and are the largest minority in Mongolia. Separated from their one-time homeland by shifting borders, they are now mostly settled in the mountainous Bayan-Ölgii province in the country's far western reaches.

Kazakh nomads have been grazing their livestock near the Altai Mountains for many hundreds of years. After the Mongolian Revolution of 1921, a permanent border was established, partitioning Mongolia from China and Russia, and so the Kazakh herdsmen were given an accidental home within Mongolia.

The Kazakhs are a different people from the Mongols in many ways. They look, speak and dress differently, and they pray to different gods, the Mongols being largely Tibetan Buddhist and the Kazakhs predominantly Sunni Muslims. The isolation of the Kazakhs' land from the

Ninety-three-year-old Orazkhan Shuinshi with his granddaughter Nazgul at their winter home in the village of Sagsay in western Mongolia.

13

rest of Mongolia only extends that divide. Crucially, however, the Kazakhs and Mongols share a nomadic heritage, living in extended families and moving camp several times a year in search of pasture for their livestock.

Having so much solitude and space on journeys to this otherworldly place is deeply affecting. The frozen air, the vastness of the plains and the never-ending skies filled with fearsome dark clouds make one feel inconsequential. But in this barren landscape, where temperatures plummet to -40°C (-40°F) in winter, live the last of the men who hunt with eagles.

When you meet the hunters, you can see the harshness of the landscape etched on their faces. Their lives are deeply intertwined with the environment, and the golden eagles that ride with them represent who they are – rugged, formidable and proud. Only the toughest survive here; there is no place for the weak or the maimed. It's sad to think that after hundreds, perhaps thousands, of years the *burkitshi* are slowly dying out. There are no more than fifty to sixty of the 'true' hunters left, and each winter claims a few more. The young choose the easier life in the cities far away. Ulan Bator, the Mongolian capital, is one of the most polluted cities on Earth, but it is where most of the hunters' children end up, looking for better opportunities.

Orazkhan tells his story in his own words:

Golden eagles are like no other bird. They want to be with you. They love you. And they love to kill for you. When the time comes to let them go, it's the hardest thing a man can ever do.

I've had more than twenty eagles in my life. Last year I released my last eagle back into the mountains. It was as if a member of my family had left. I think about what that eagle is doing; if she's safe, and whether she can find food and make a nest. Have her hunts been successful? Sometimes I dream about these things.

This is a hard land, a big land with very few people and a lot of space. The environment has changed since my childhood. The winters used to be a lot colder and longer, and there are fewer eagles now making their nests around these parts. Maybe they migrated to somewhere else.

This tradition is dying, and there are fewer and fewer old hunters these days. You can have an eagle, but that doesn't make you a hunter. In the old days, if you didn't have an eagle next to your home you weren't a real man.

The eagles are just like us: they get smaller as they get older but also become wiser. Just like us, they learn from the past and they remember – mountains, valleys and the shape of the land. After we train them, they will not escape from us. But after many seasons have passed, we should not wait until they die. We should let them go back to the wild to live out their lives.

Our traditions have not totally disappeared, but we are the last of the true eagle-hunters. The young generation today aren't interested, and there are many things that keep them busy, such as earning money and listening to music. They seem to like going to the capital. We should train our children to keep this tradition alive. This is who we are.

Eagle-hunting is not easy work. You have to prepare your horse, and you must be healthy. You go hunting early in the morning, even in cold weather and snowstorms, and sometimes return days later. But now people find this difficult. They want only to be inside, in the warm, and they keep their eagles just for festivals and treat them as pets. The people are lazy and that makes the eagles lazy. Eagles are wild fighting birds. They are not something to hang on the wall like a carpet.

To the young I would say: the golden eagle is a holy bird; treat eagles as your children. Love and respect them. If you do this, they will give everything back to you.

THE PARTNERSHIP

It is the bond between hunter and eagle that fascinated me and brought me to this project of documenting the *burkitshi*. The hunters all had stories about how they loved their birds even more than their wives. And there's a Kazakh saying that if a hunter's father dies on the day the snow starts to fall, the hunter won't be at the funeral because he'll be up in the hills with his eagle.

In this part of the world, because there are no tall trees, the golden eagles build their nests high on the rock face, wedged between sharp clefts. This is where the hunters go in search of a young bird. They are looking for an eaglet of about four years old that has lived in the wild and been on a hunt; not so young that it won't survive without its mother, but not so old and experienced that it cannot be taught to live with humans. Only females are taken, as they are larger and more powerful and aggressive than the males – with a wingspan of 2.5 metres (8 ft) and weighing up to 7 kilograms (15 lb) when fully grown.

When the hunter takes the eaglet from its mother, a huge responsibility comes with that act. 'You love them as your own, even when you set them free at the end', one hunter told me.

The hunter takes the eaglet back to his home, and there the hand-feeding starts, with pieces of horse, sheep or yak meat. The bond between man and bird begins developing at that point, as the bird learns to trust the one who feeds it. That trust, I've been told, becomes love – and that's when the hunter takes the eagle on a hunt.

The question that's foremost in your mind when you witness a hunt is, why doesn't the eagle fly away once the hood is lifted and the bird is released into the air? It comes back to the hunter quite simply because it feels it is part of the family.

Golden eagles can live for up to thirty years, but they are kept only until they are a little past their prime, about ten to fifteen years after their capture, when they have done their job and earned their freedom.

Then a hunter will take the bird far from his home, let it gorge itself on meat and set it free. This is not an easy task, as the eagle will often follow the hunter back; the hunter may have to wait until dark to make his escape.

One hunter told me a story about how he was riding in the mountains with his friends, many hours from home, when they saw two eagles circling overhead. He said to his friends

that he recognized one of the birds as an eagle that he had released into the wild many years before, but they were disbelieving and laughed at him. He stopped his horse and called out with a high-pitched squeal. To the astonishment of the other men, the eagle came flying down and landed on his arm while the other continued circling. He stroked the eagle's head and after a while held his arm aloft and invited it to fly off, which it did. Not only was he was overjoyed to see his old friend, but also delighted it had found a new friend with whom to share the skies.

When the *burkitshi* tell such stories, their normally calm voices become animated and their body language changes as they gesticulate and point to the heavens. Then you begin to understand the huge importance the golden eagle plays in the souls of these last remaining Kazakh hunters, for whom the eagle encapsulates the open space, the wind, the harshness, the isolation and the freedom of living on the edge of the world.

One night, sitting by a fire, I asked a hunter named Ongar what goes through his mind during the lonely days and nights out in the elements, finding pasture for his sheep and yaks and protecting them from wolves. After a long silence he replied, 'I listen to the wind.' The next day, as we travelled high on a mountain pass, Ongar discovered some of his precious sheep had gone missing. He set off on horseback with his son Kuanbay, abruptly leaving me and my translator behind. I sat in a rocky crevice and found myself listening to the wind roaring around the contours of the mountain and whipping the grass, ever-changing in tone and volume, and becoming deafening at times. As the hours wore on, I thought about everything but also about nothing, and felt utterly at peace. With only nature's symphony and my silent guide for company, I experienced one of the most memorable moments of my time in Mongolia.

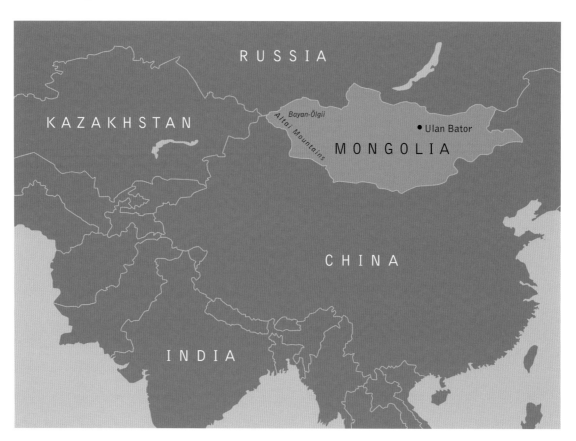

THE HUNT

The golden eagle is a perfect predator, with an awe-inspiring wingspan, a beak built to rend flesh, and talons that can kill prey instantly by piercing the heart. A fox is easy prey, and when hunting in pairs, eagles are capable of bringing down a wolf. They look noble and distinguished – just like their masters. And their eyesight is amazing, markedly better than a human's; their eyes seem to burn with a real intelligence and ferocity.

The birds are calm and exude confidence when they head into the hunt. After the *tomaga* (hood) is lifted from its head and it sees the fox in the valley below, the eagle takes its time waiting for the right moment. Then, without warning, it will raise its wings and dive like a bullet, leaving a rush of air in its wake as the hunter makes a screeching sound, urging it on. Within moments the eagle reaches its prey, sinking its claws through the fur and skin. Fox meat makes a welcome winter meal for the hunter and his family, while the pelt is kept as a trophy or made into hats and other items of clothing.

Even though the eagles are kept in the hunters' homes, they remain wild birds with a finely honed killer instinct. As I was setting off one afternoon after spending a few days with a hunter and his family, an eagle tethered outside the *ger* without its hood swooped suddenly and sank its talons into a toddler. The quick reaction of one of the men near by, together with the child's thick coat, saved his life, although a scar on his cheek will probably be evidence of the incident for the rest of his years. The hunter told me later that he couldn't punish the bird, because it was important to maintain its love of the kill.

SHARING A LIFE

All the men I've spoken to describe the eagle as part of the family, even as their own child. And when you spend time with them, you soon see that this is true in every respect. The birds are in the home with the hunters most of the time except during the day in the summer months or the warmest part of the winter day, when they are placed outside. They take pride of place in the home, and when guests come to visit, the weather and the eagle are the first things they talk about.

Many of the hunters I've met say they have good days and bad days with the eagles, just as they have with family members. One hunter told me he often has dreams about eagles. His wife – in the background, where she was lighting the fire – muttered, 'More dreams about eagles than of me these days', to which the hunter replied, 'It happens as you get old.' And they both laughed.

As I was saying goodbye to my friend Orazkhan, he took my hand, wished me a safe journey and said, 'It was good to see you again. It will be the last time, I think, as the next winter will get me.'

I hope this book will be a record of these proud men and their noble eagles, in this magnificent, remote and unforgiving part of our planet.

On a bitterly cold morning Aibek Mana stands on the edge of a cliff with his eagle on his arm, encouraging the bird to swoop on the prey below. Just moments before he had lifted the leather hood that shields its eyes.

Pages 20–21:
Seen from a high mountain pass, sheep and yaks graze in a snowy valley, watched over by a herder.

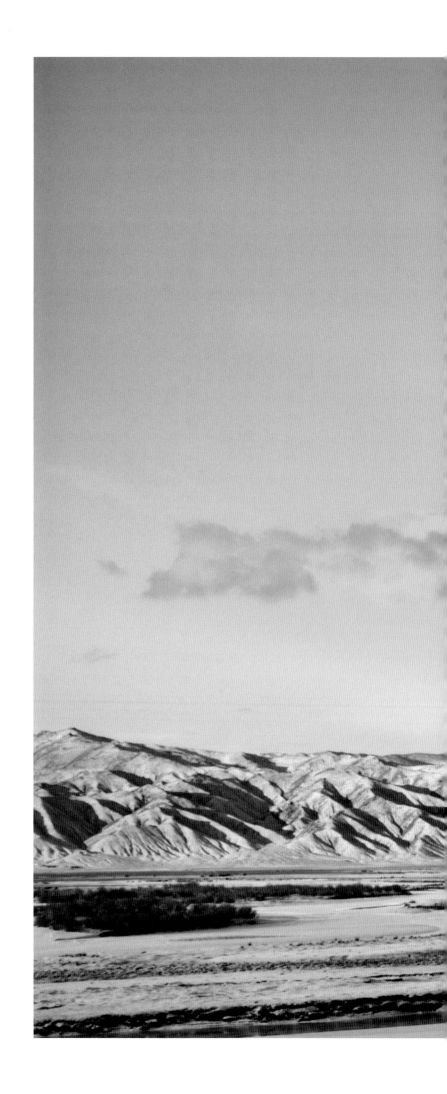

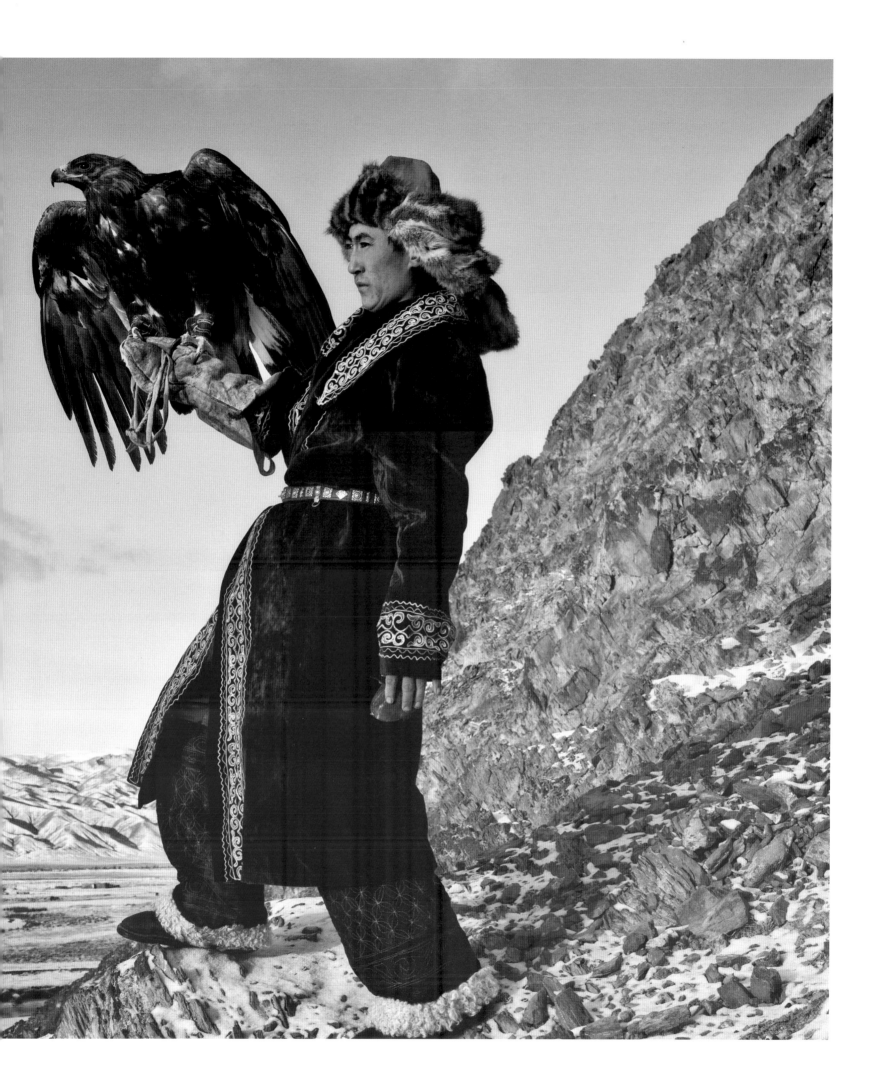

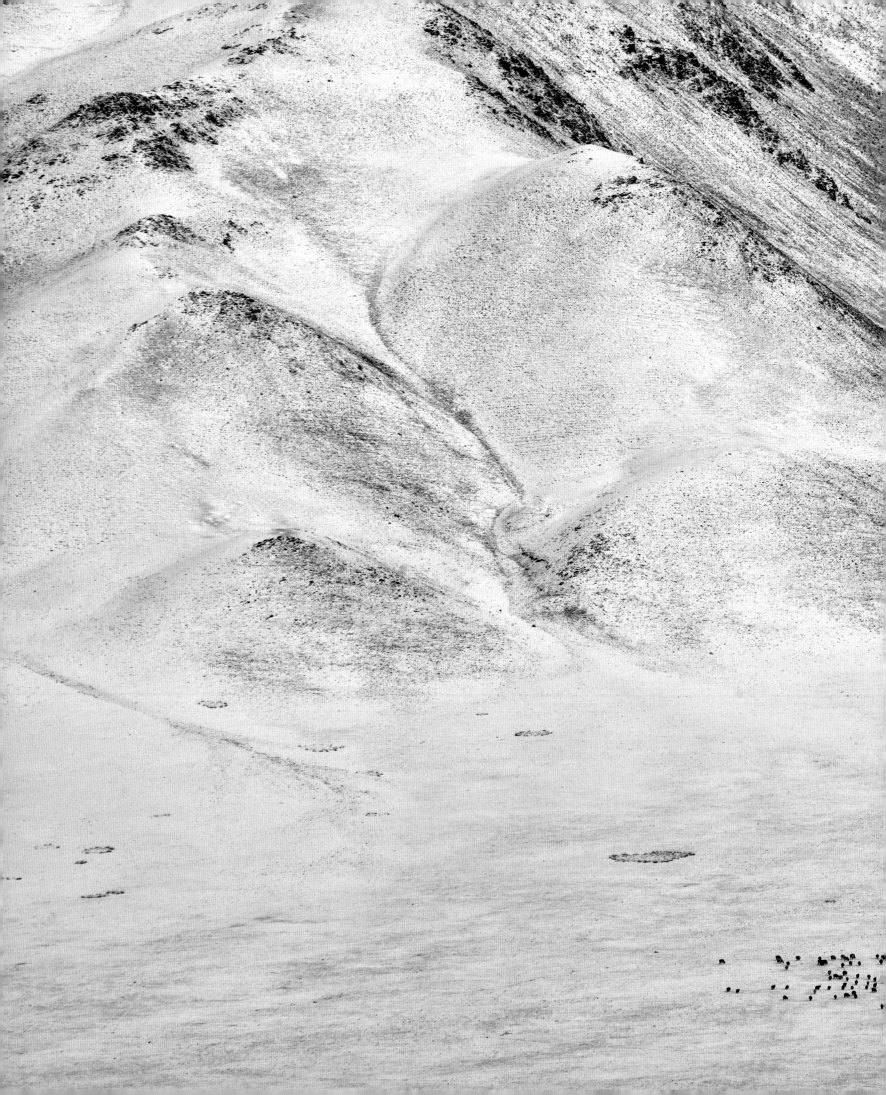

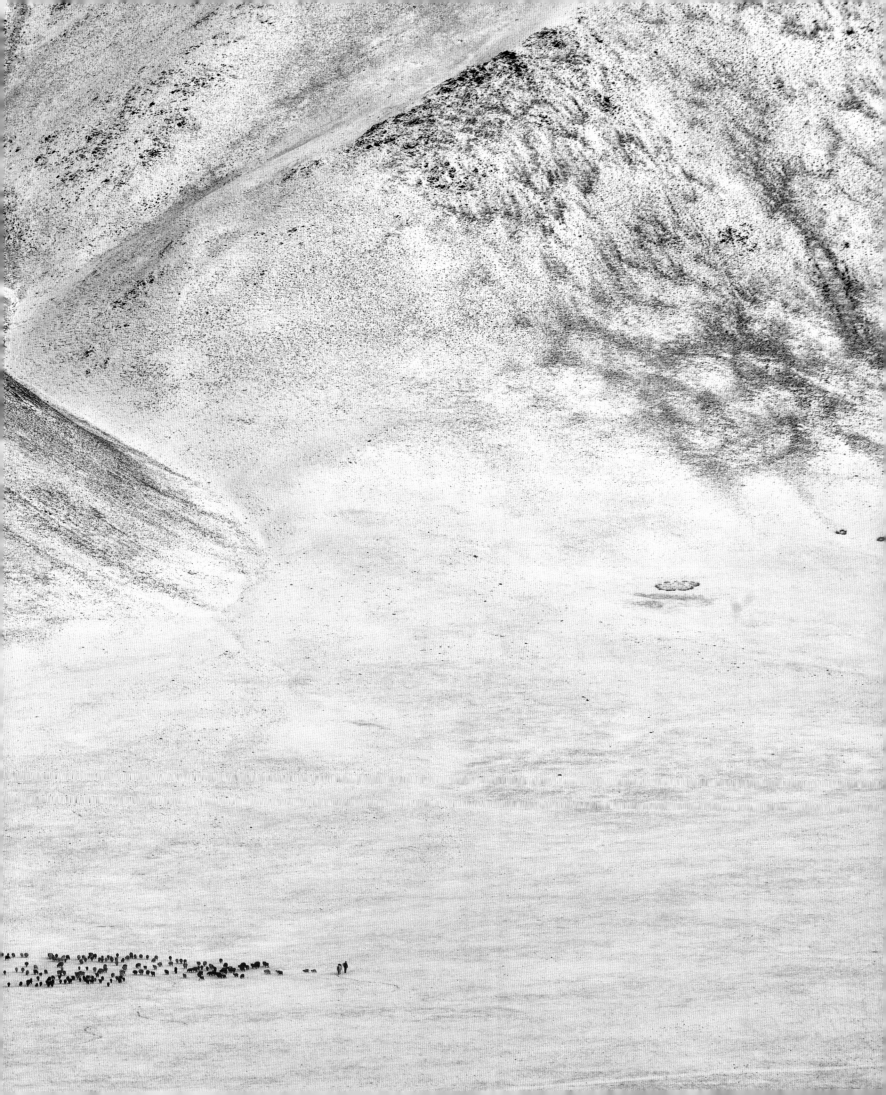

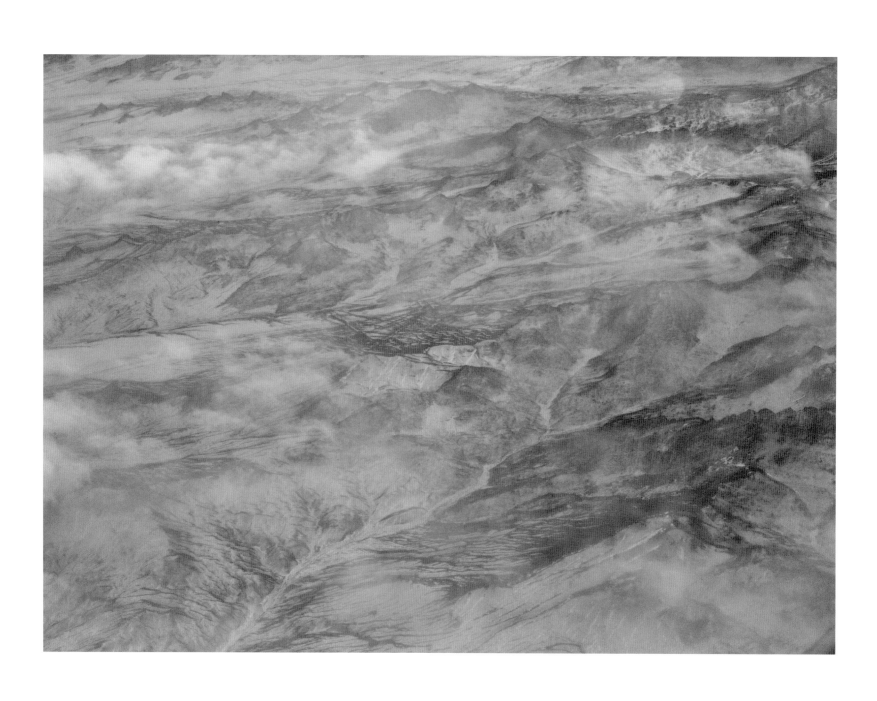

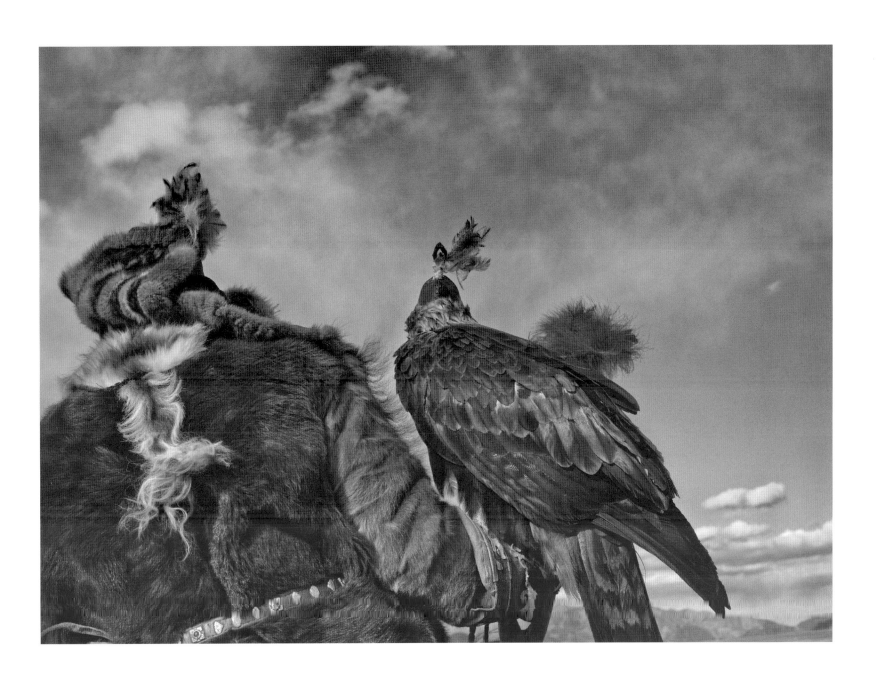

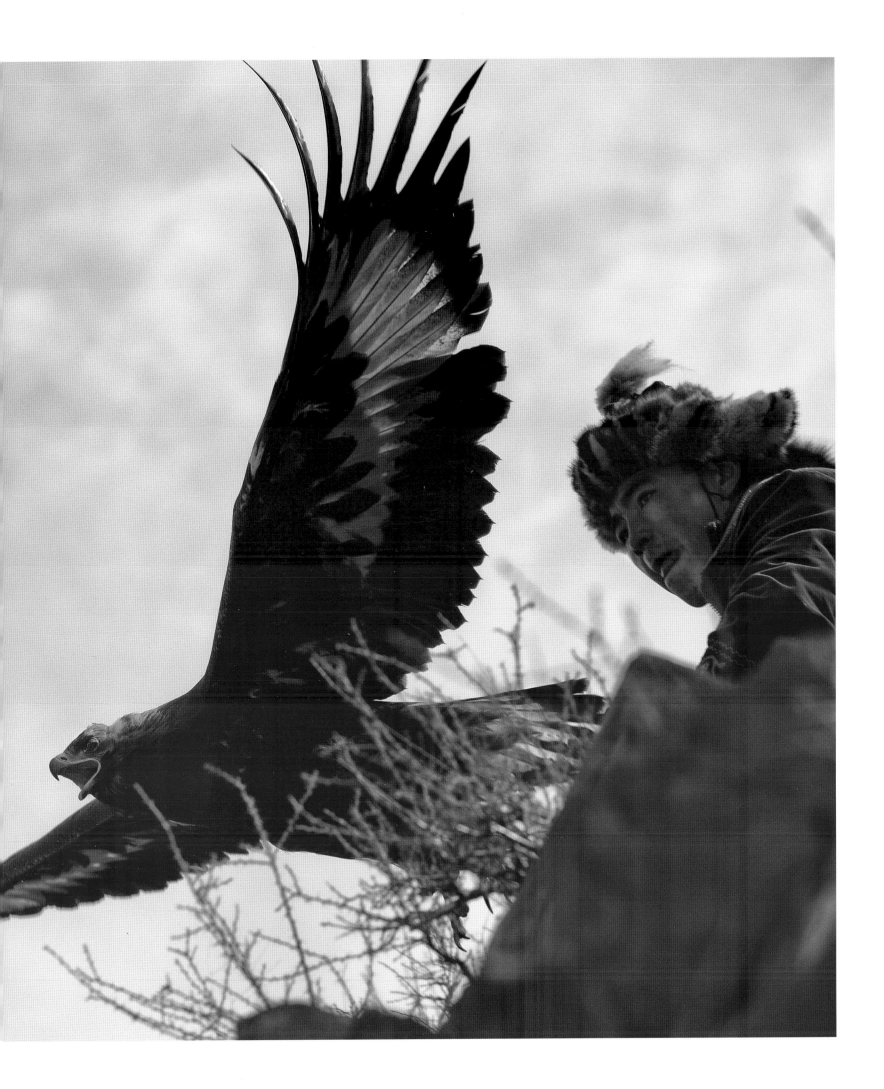

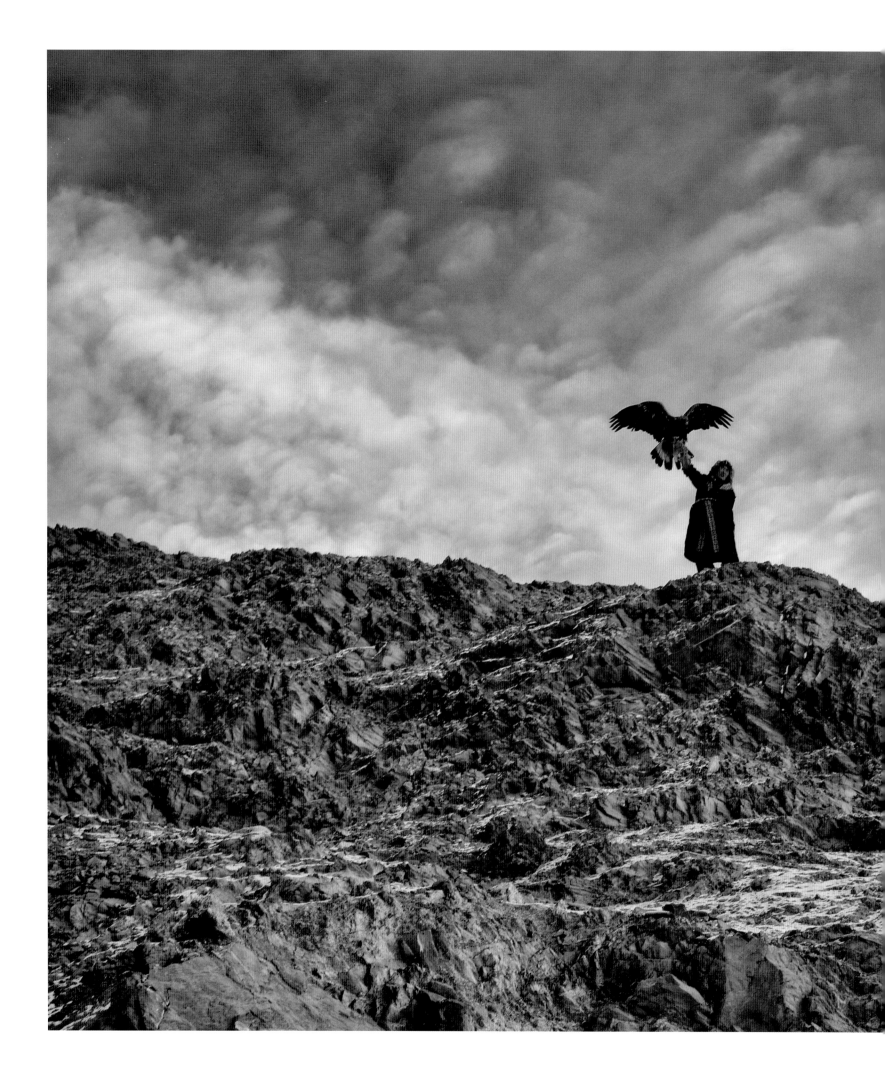

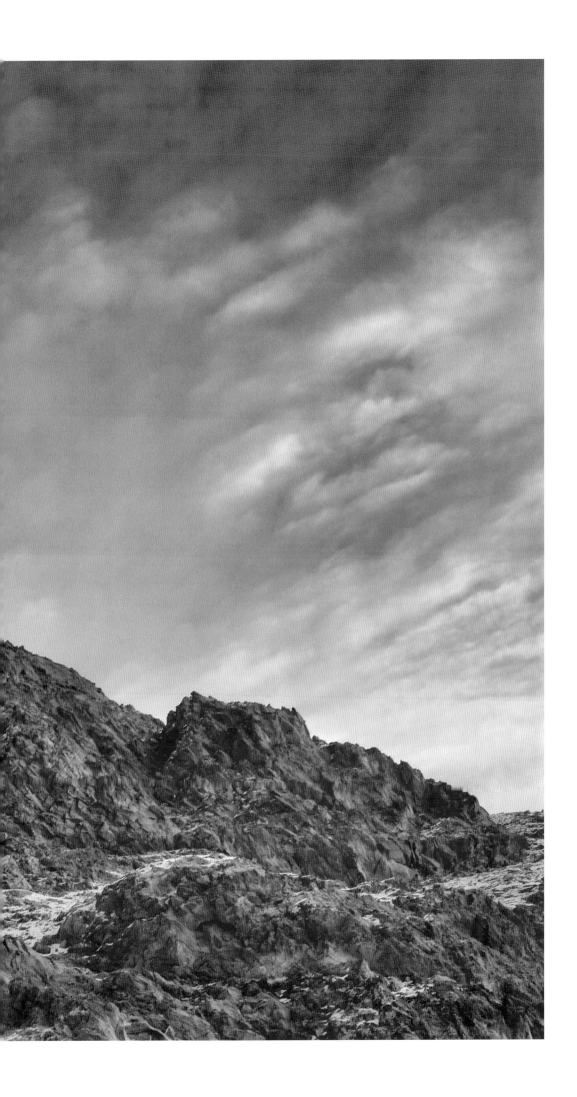

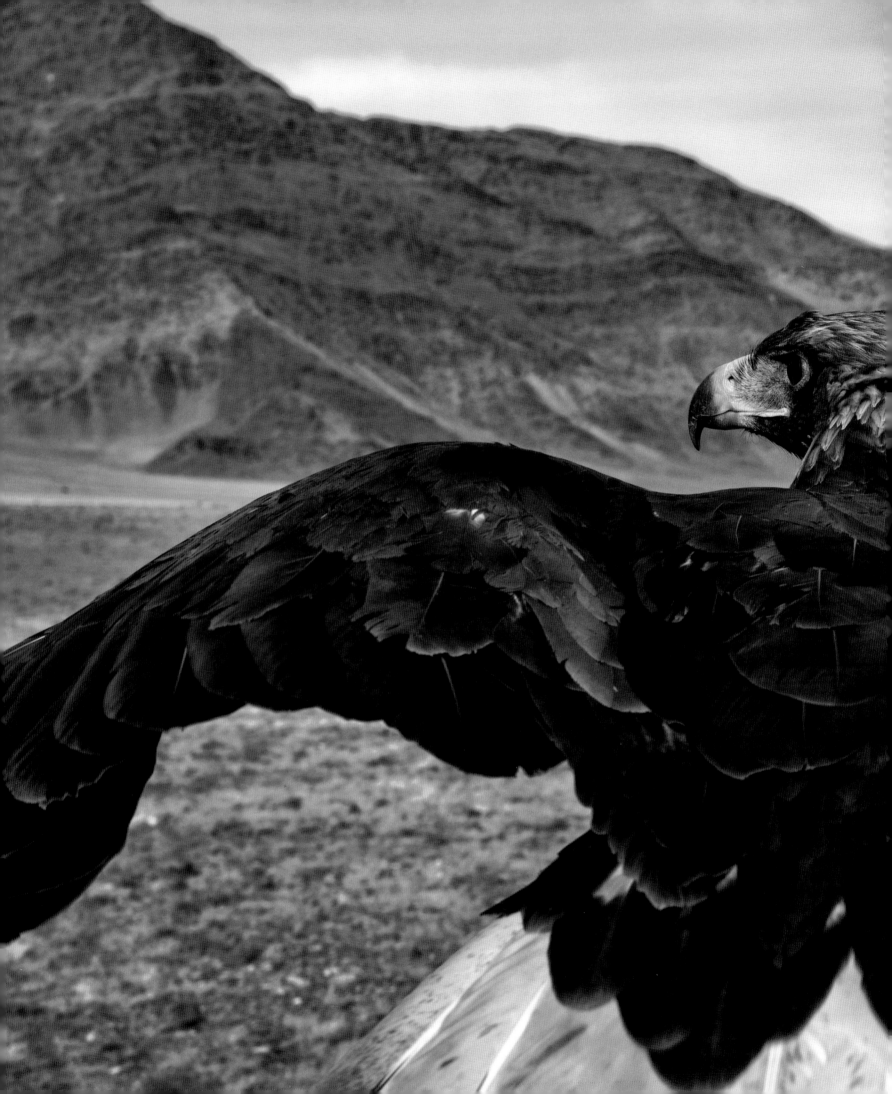

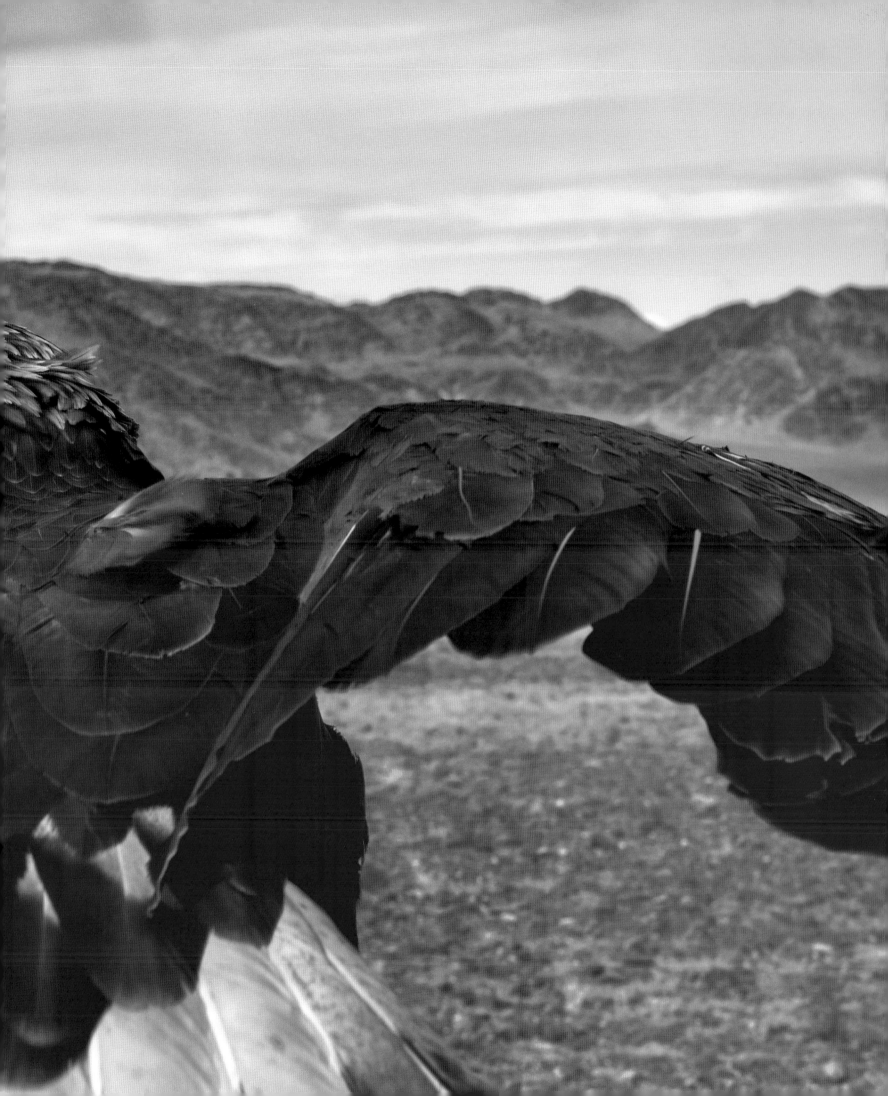

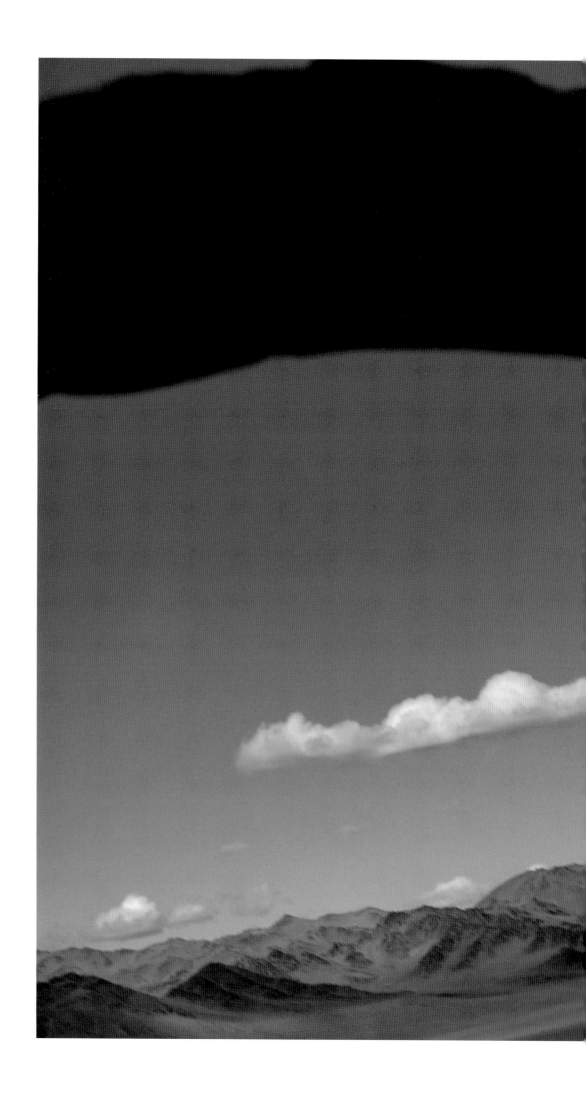

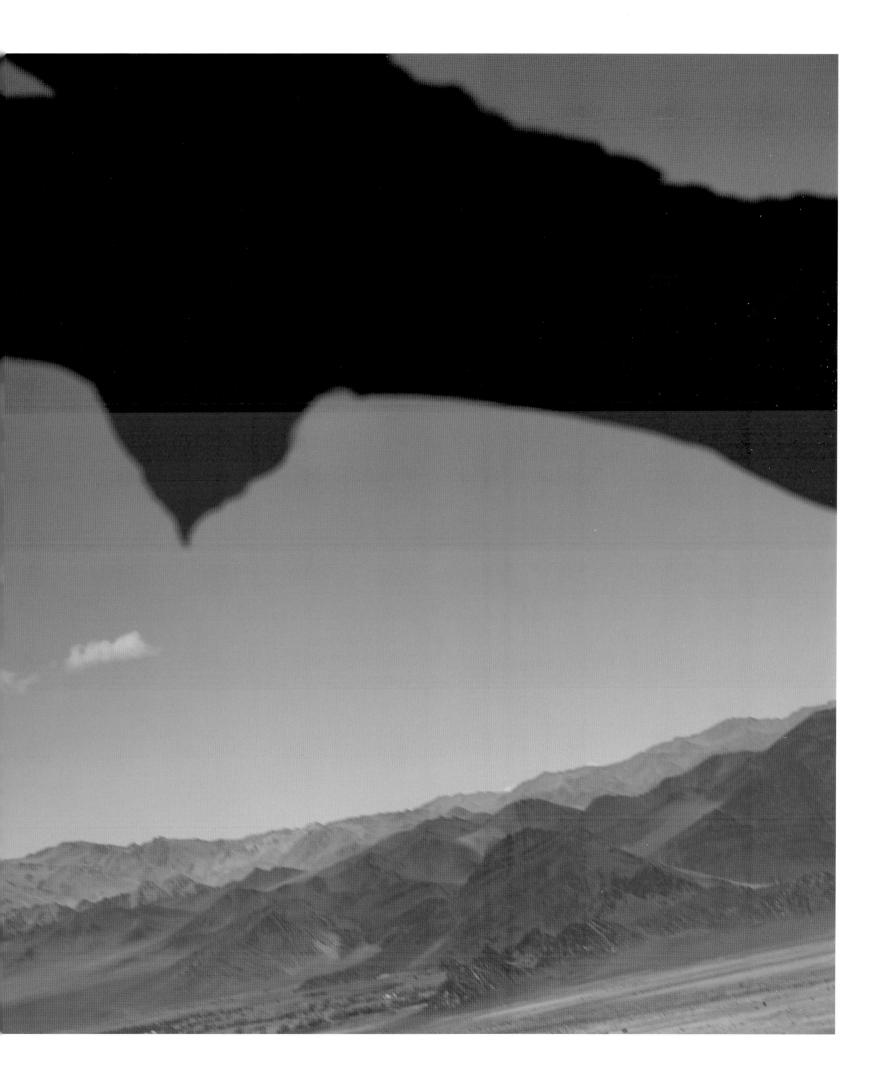

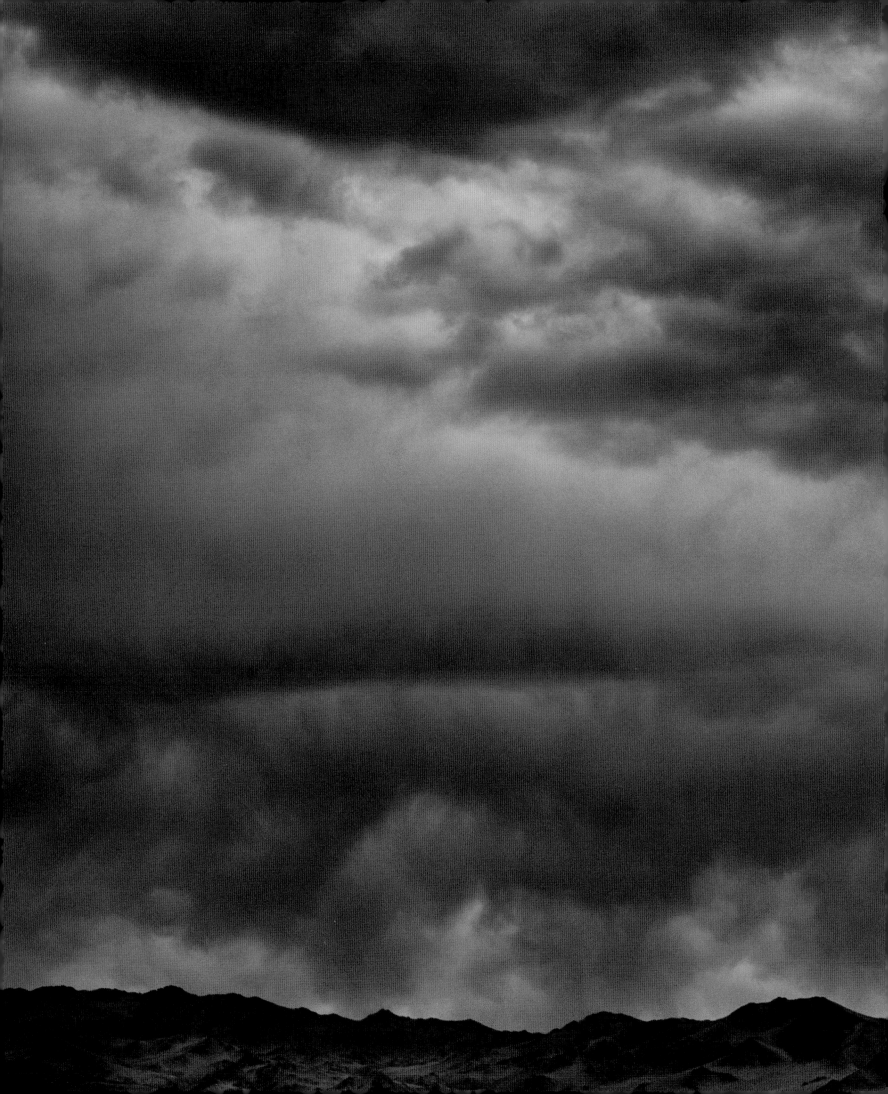

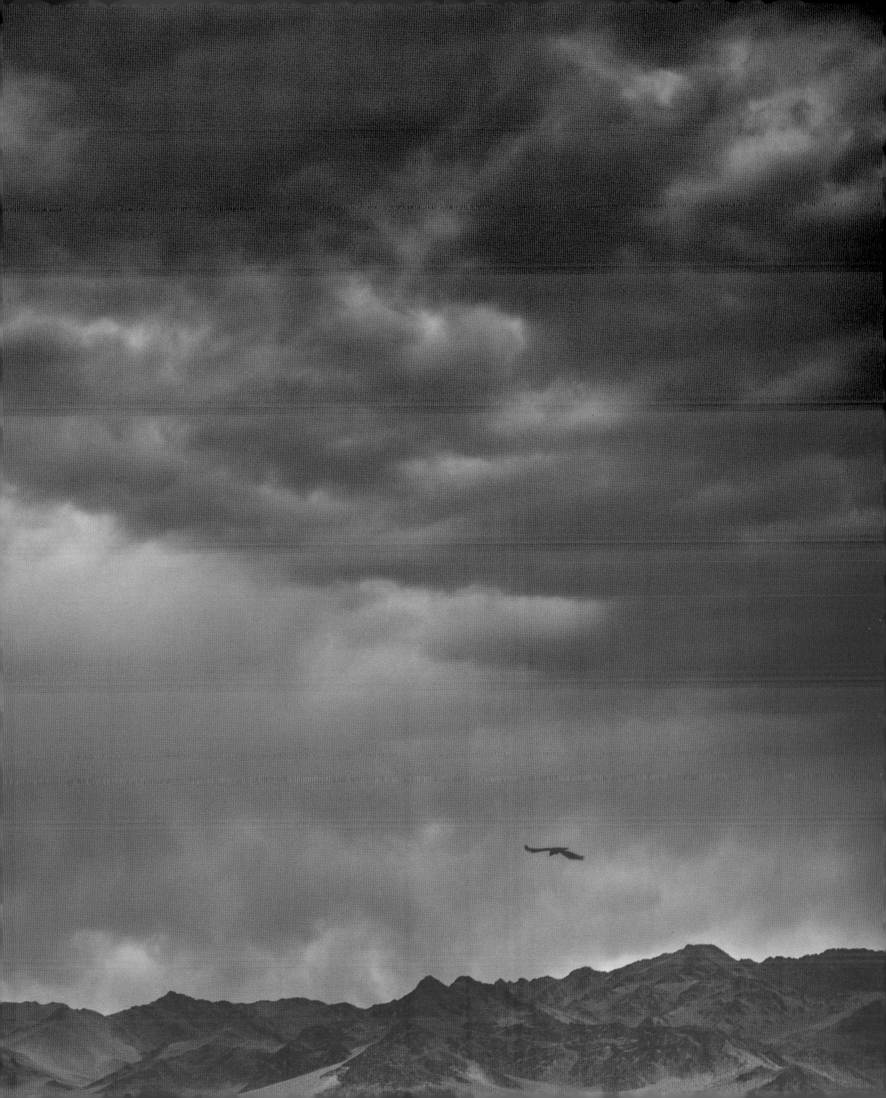

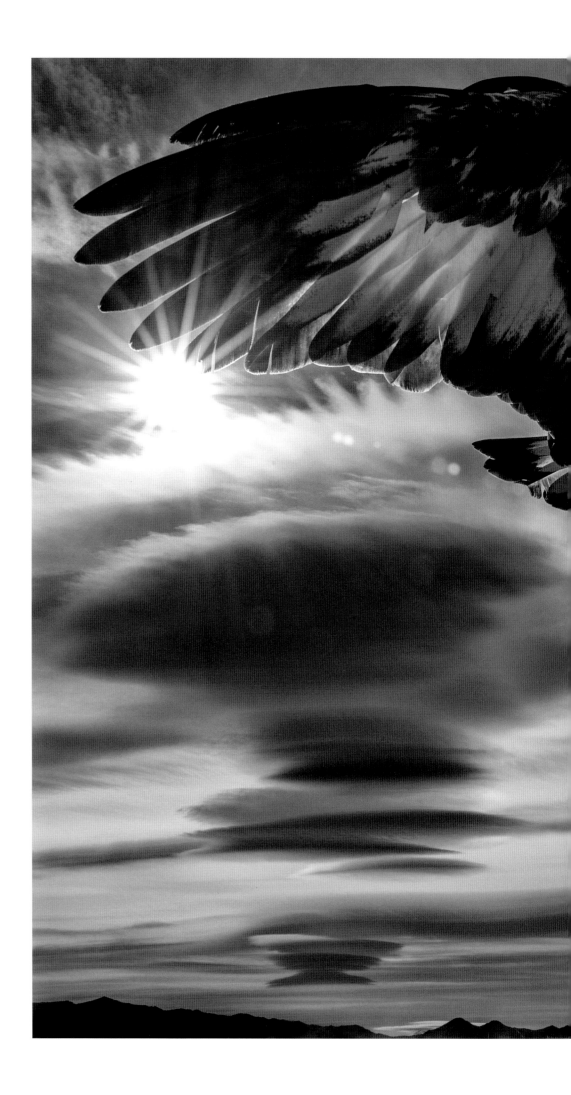

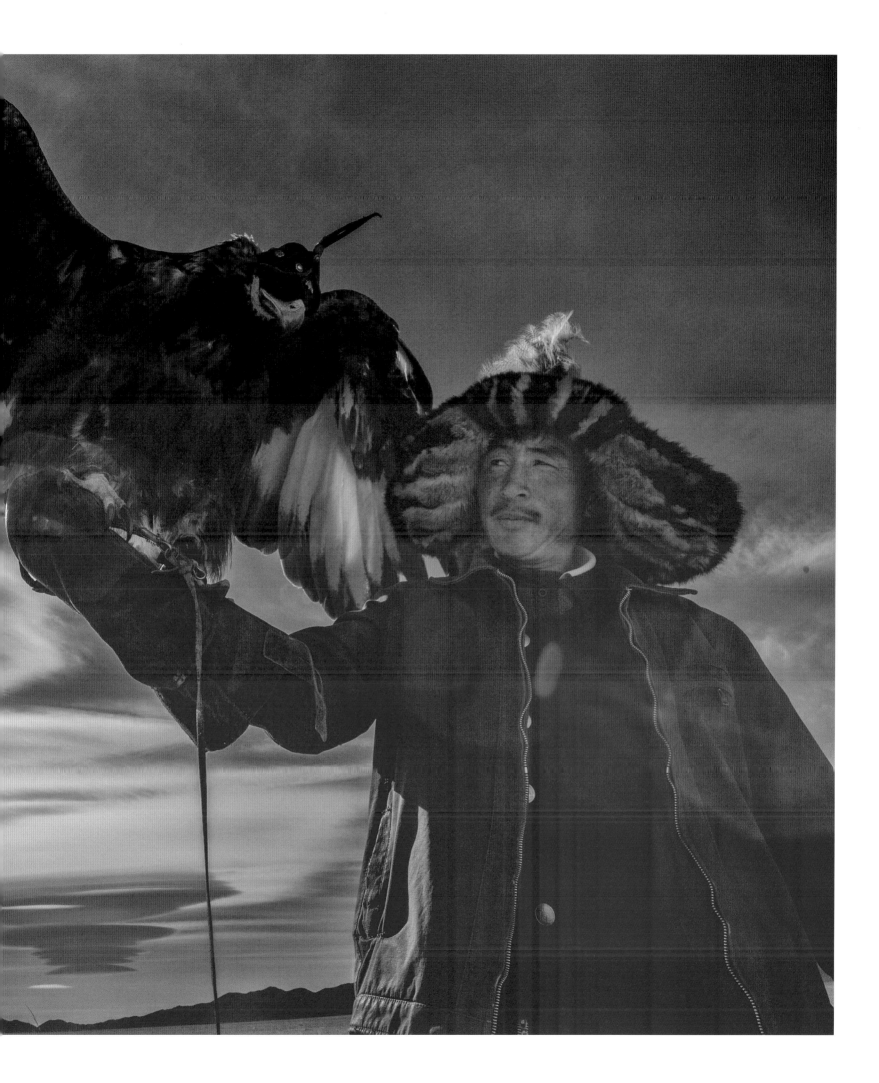

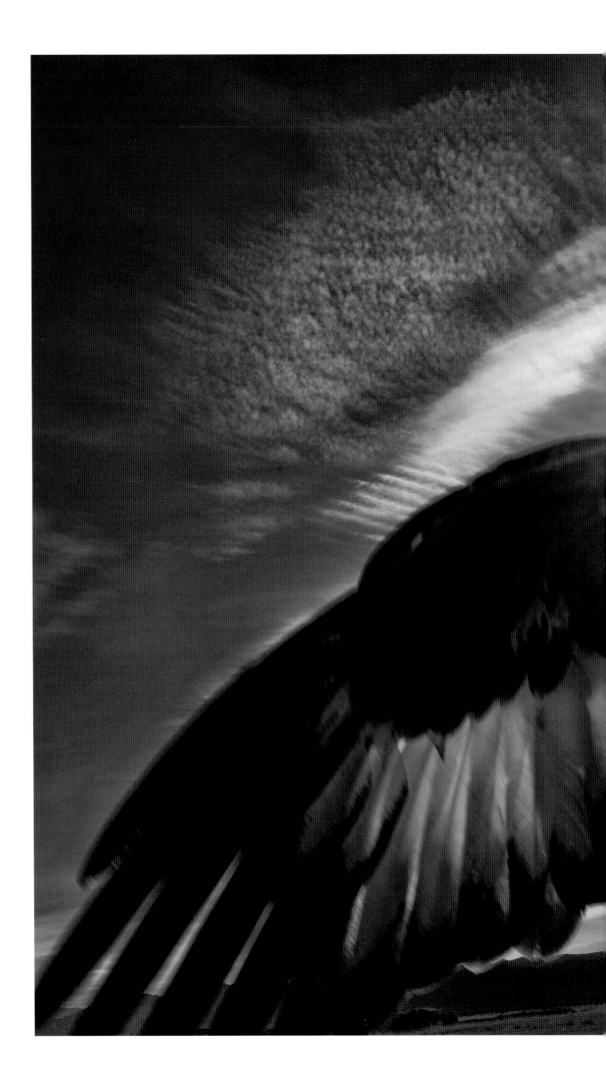

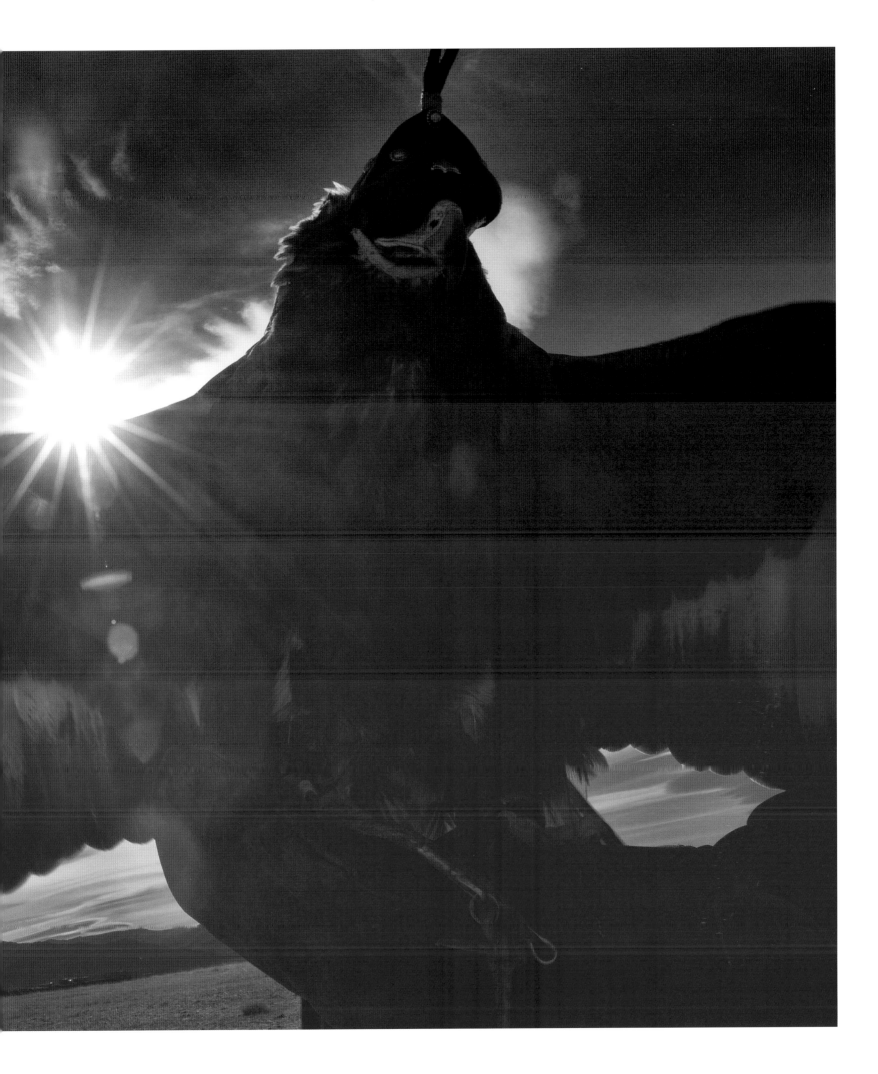

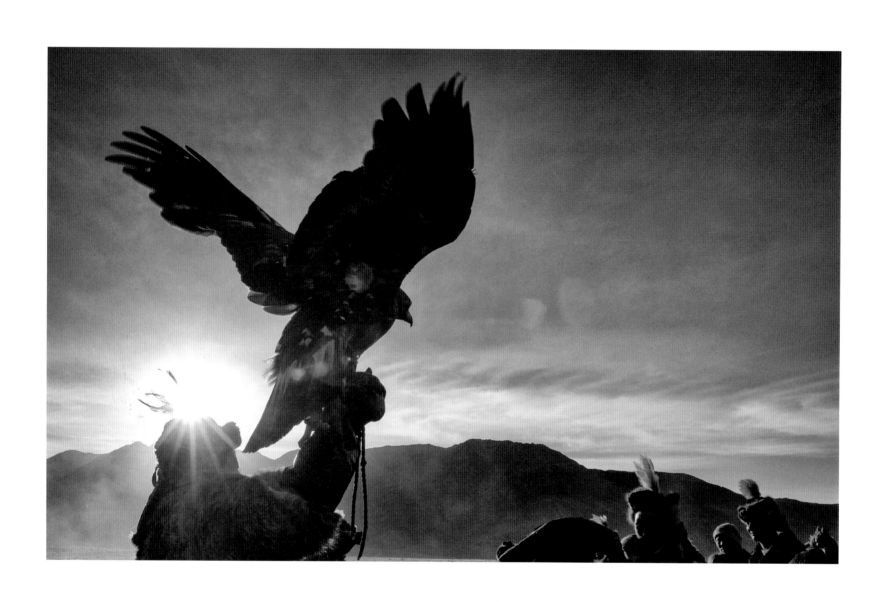

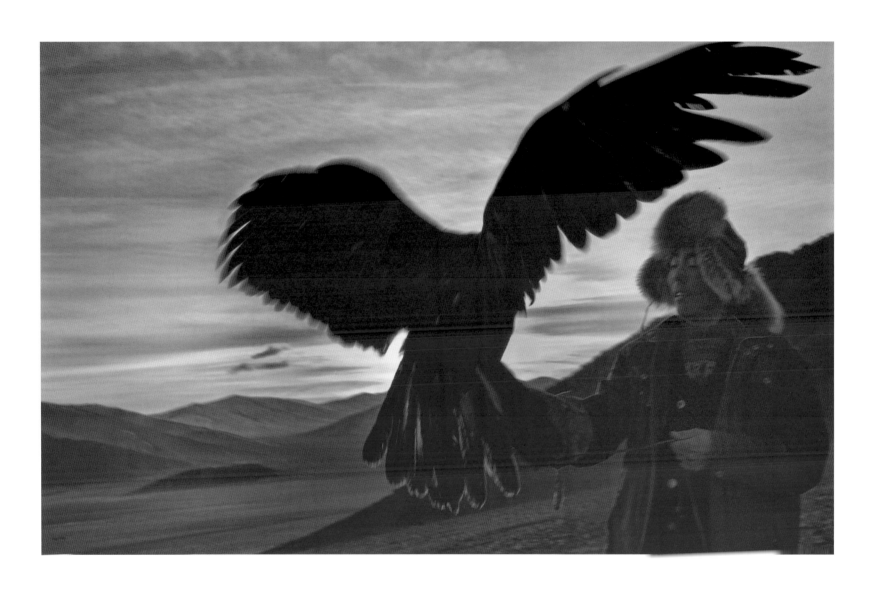

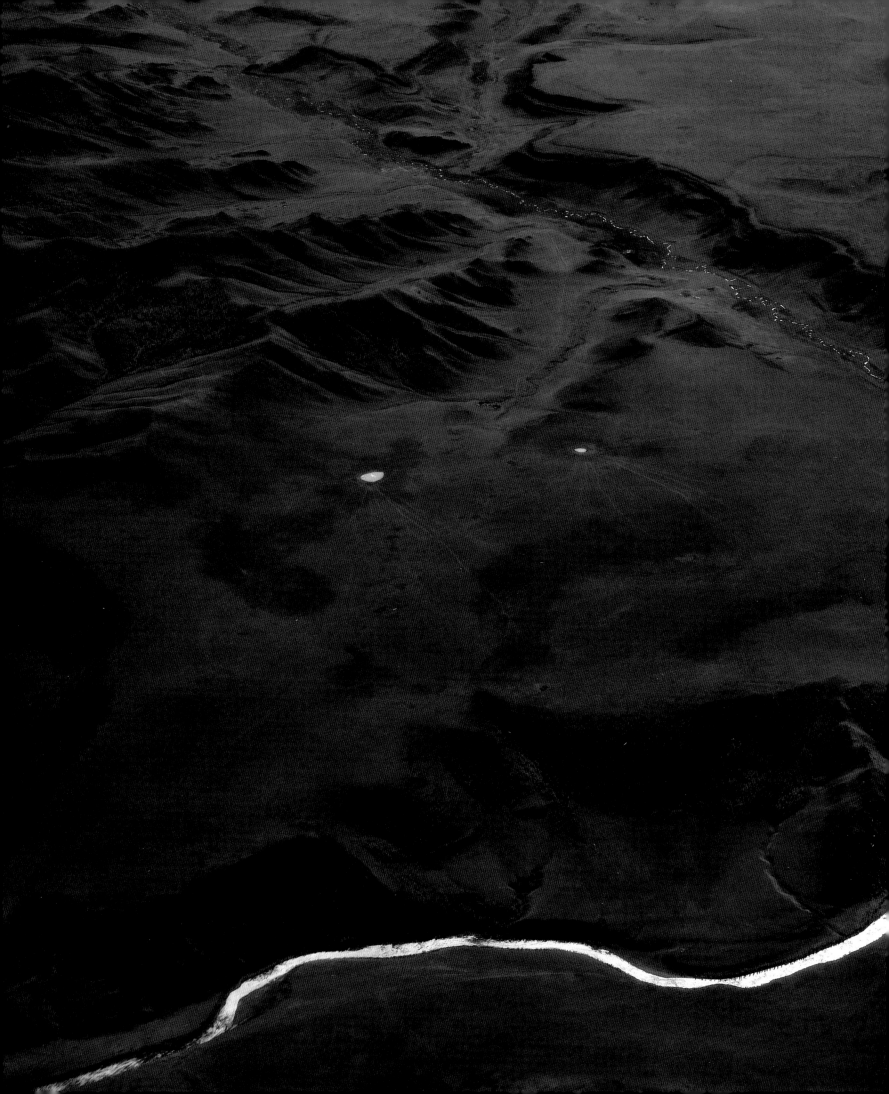

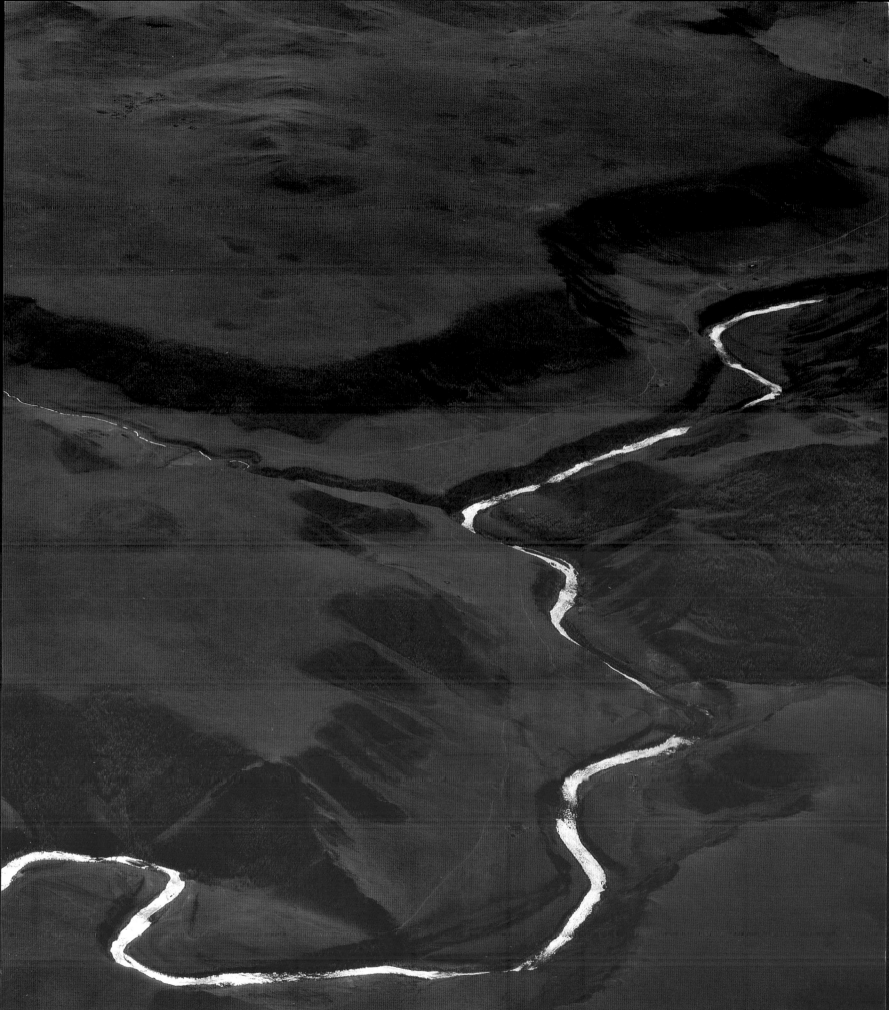

Large and grumpy, the two-humped Bactrian camel is perfectly suited to the cold and the wind. The nomadic Kazakhs use camels to transport their *gers* as they search for pasture in the summer months.

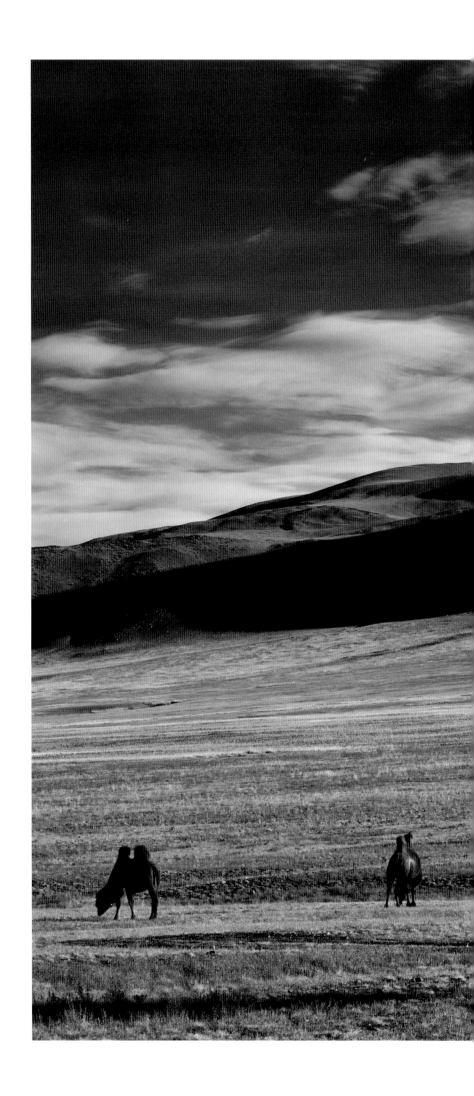

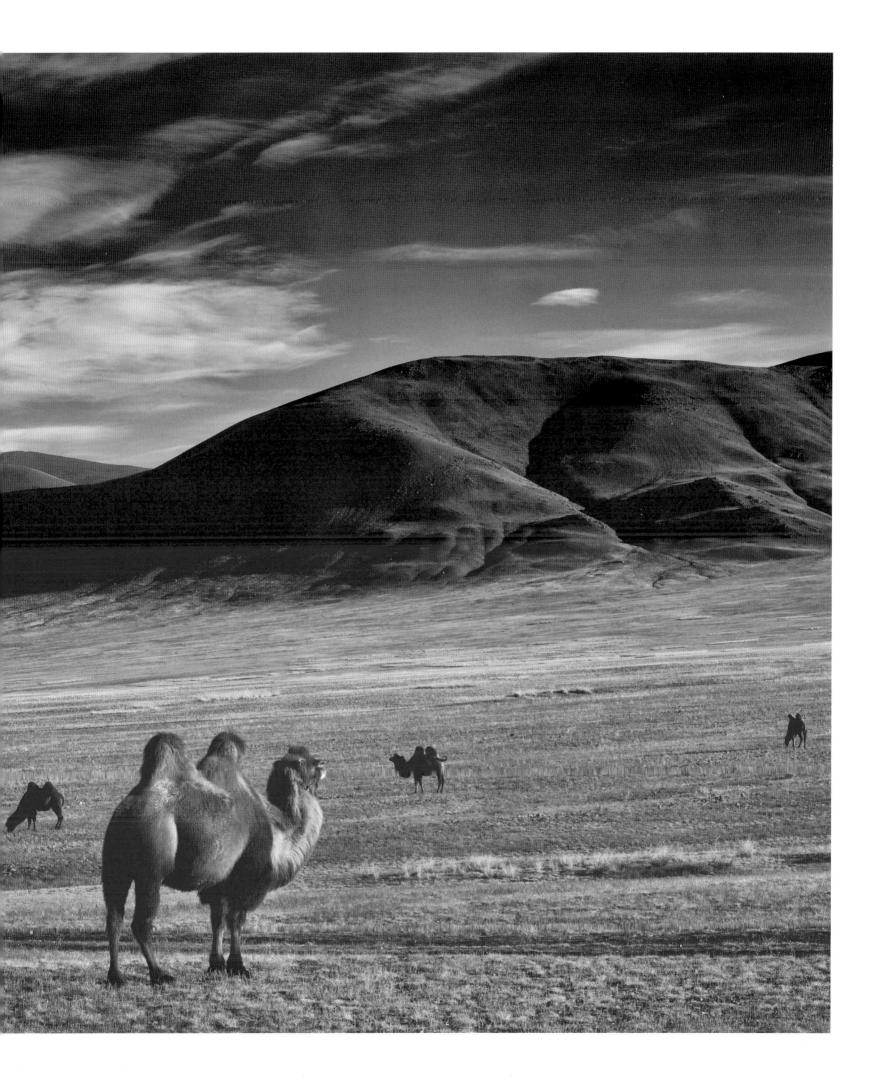

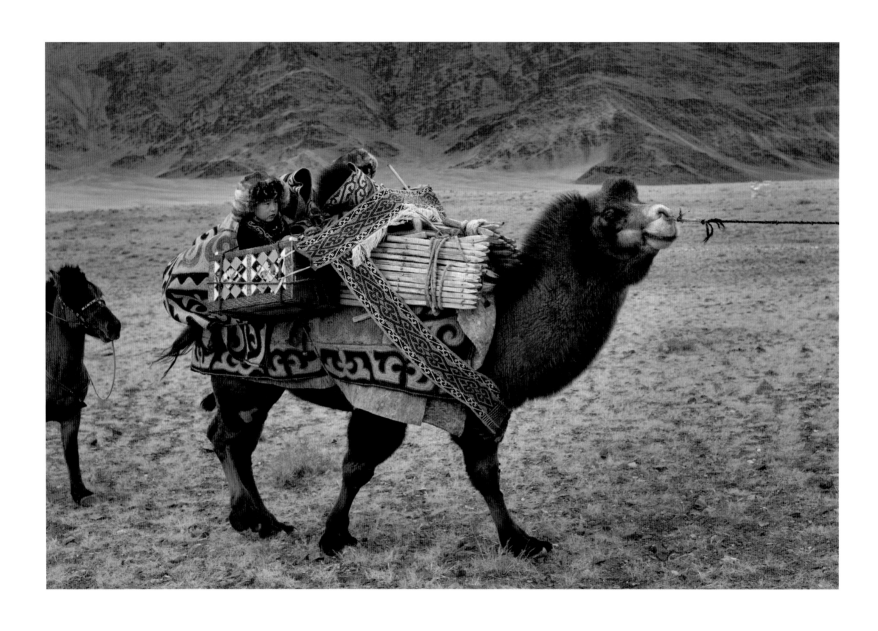

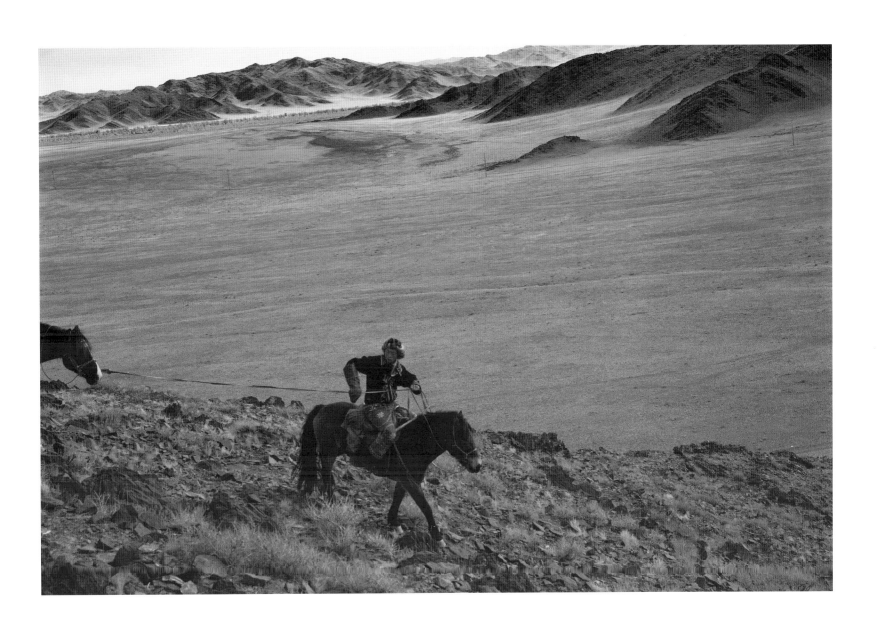

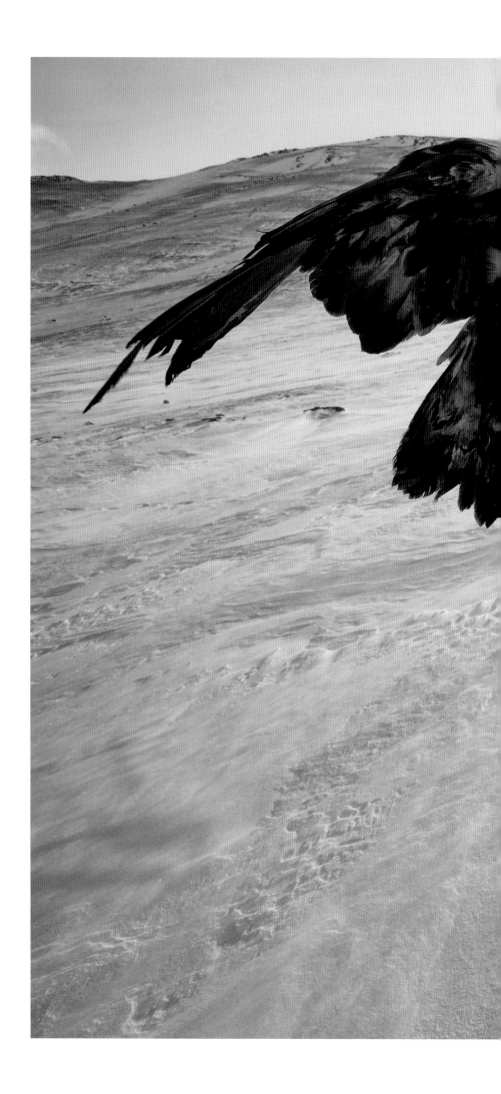

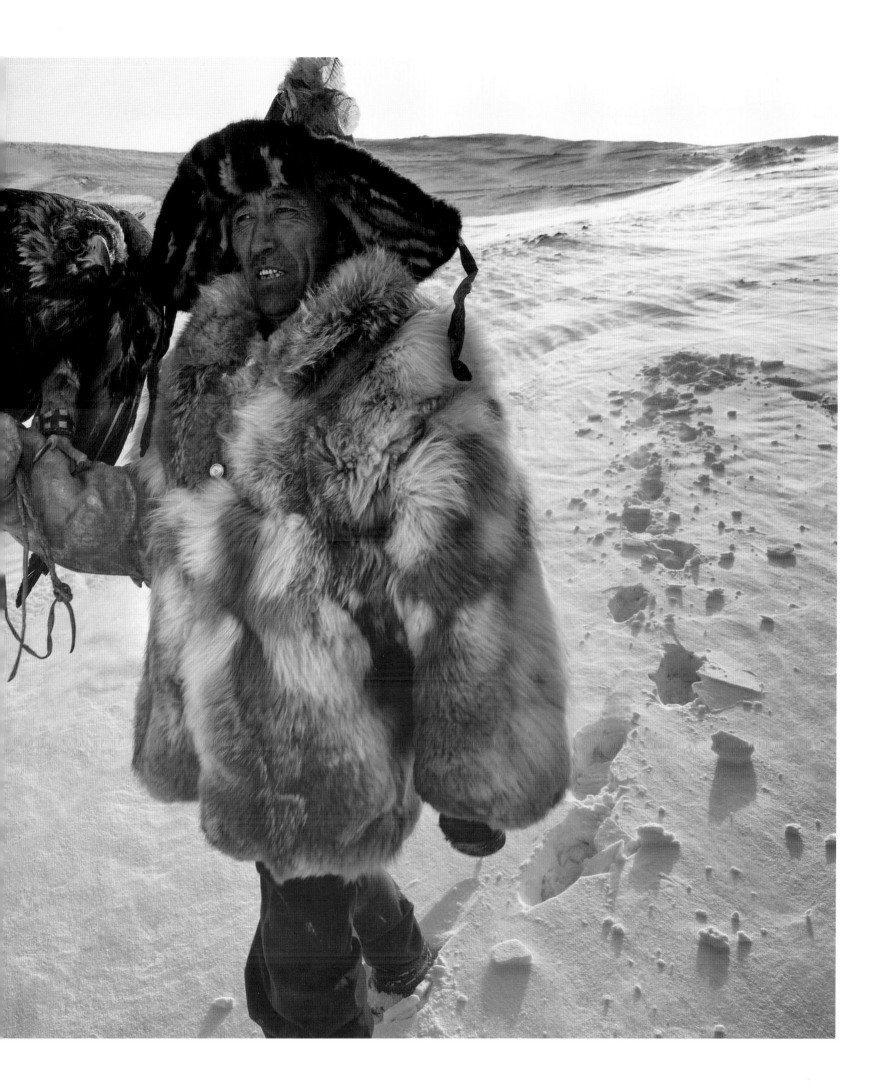

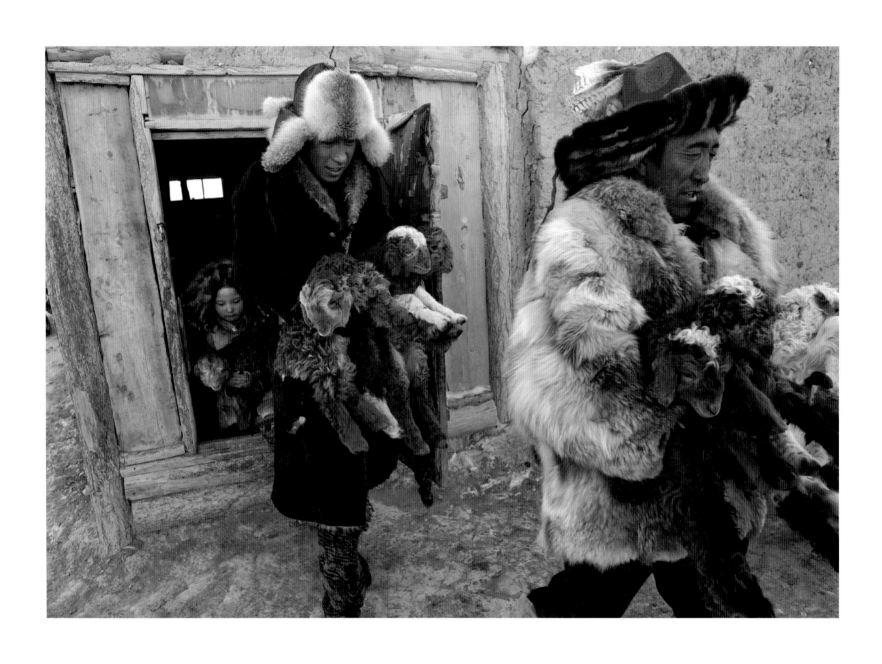

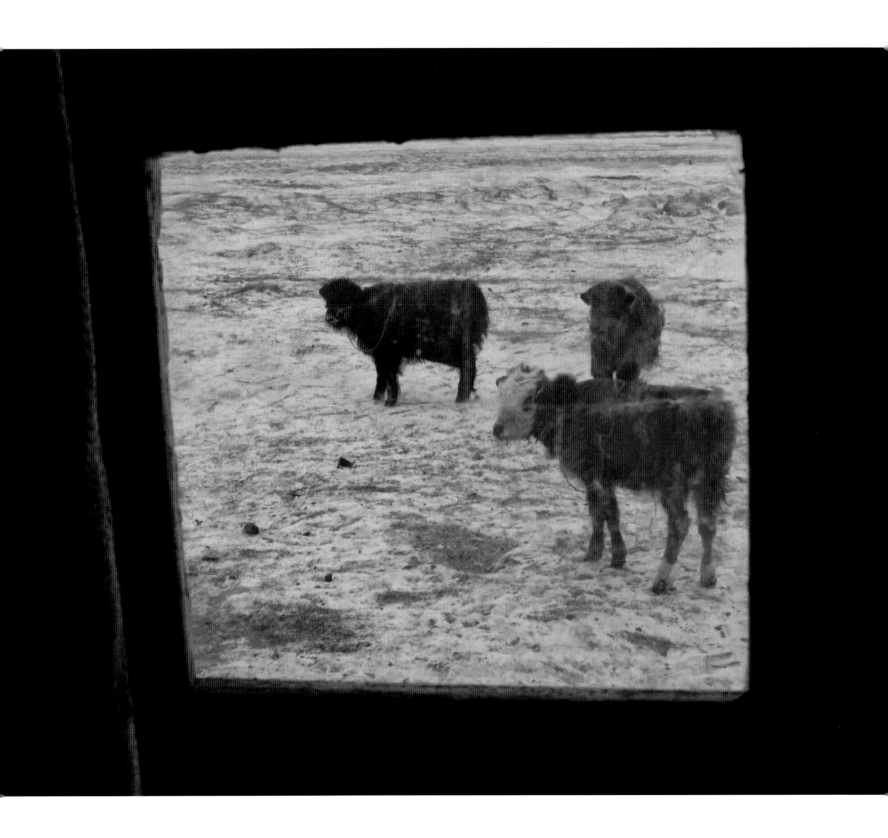

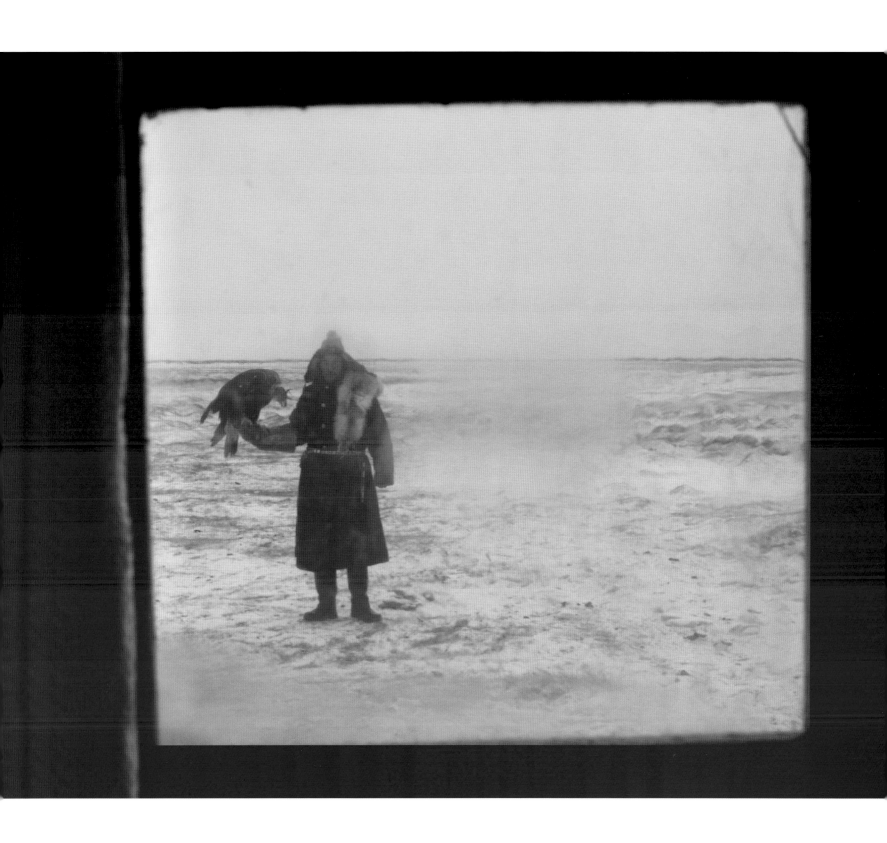

A golden eagle sits in a hunter's winter home with a *tomaga* (hood) over its face to keep it calm. The hood is taken off only when it is time to hunt or eat.

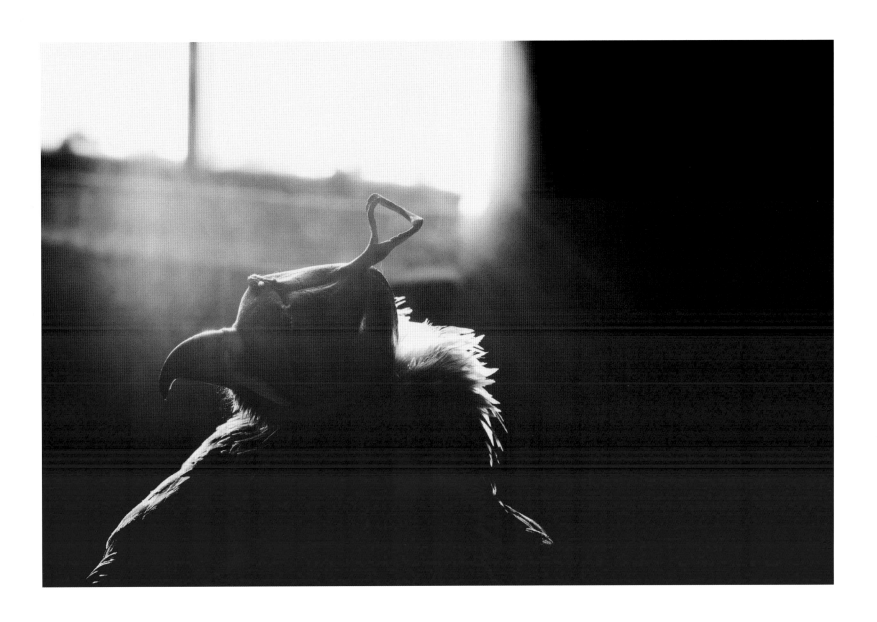

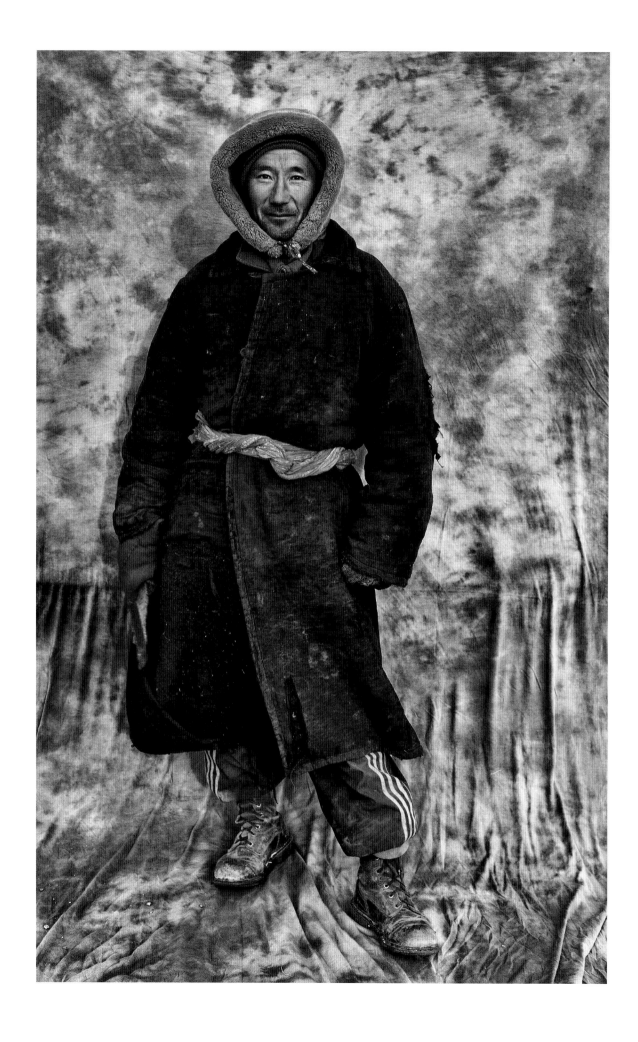

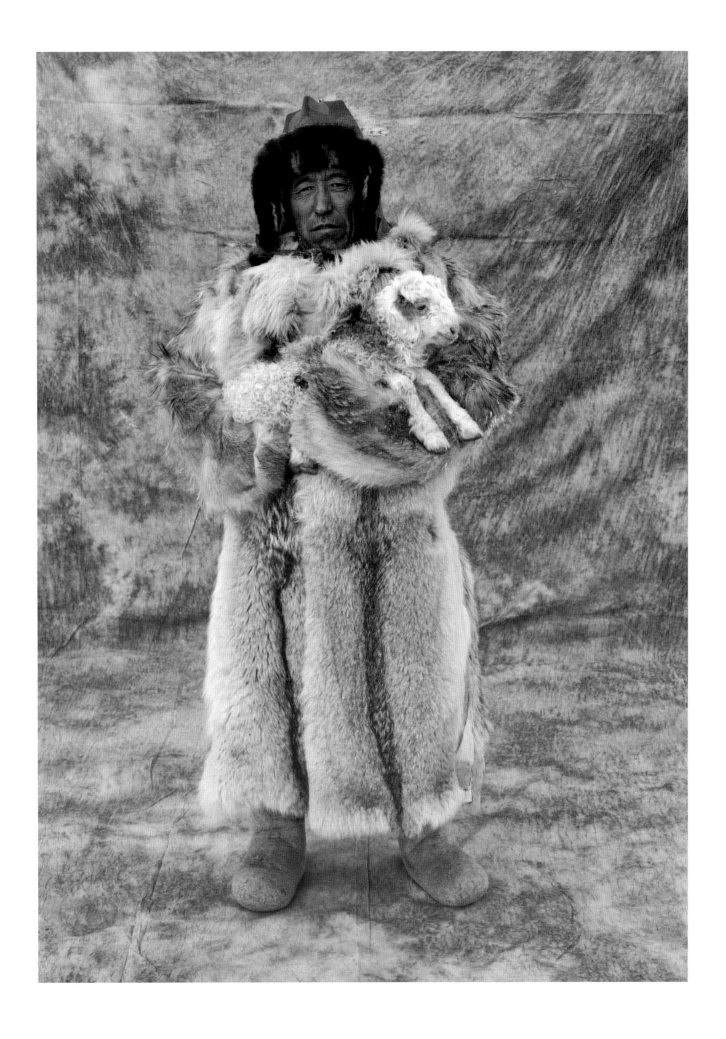

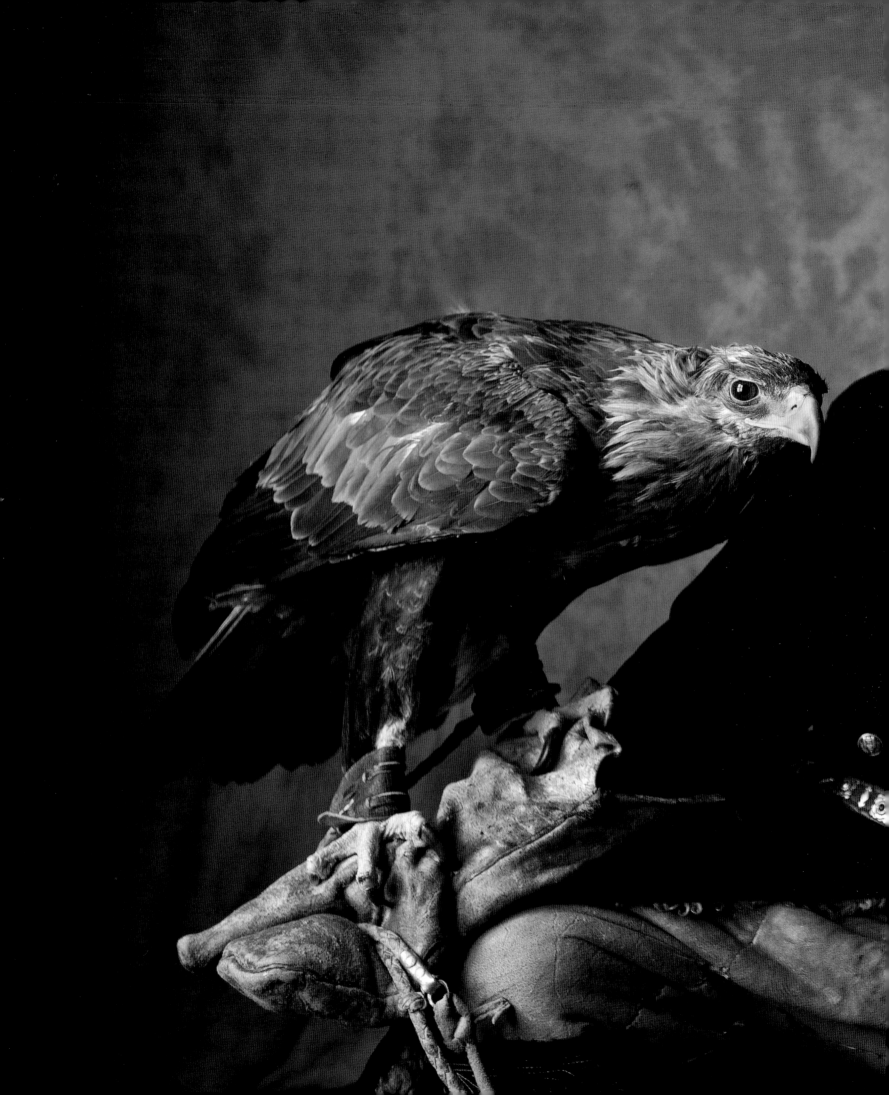

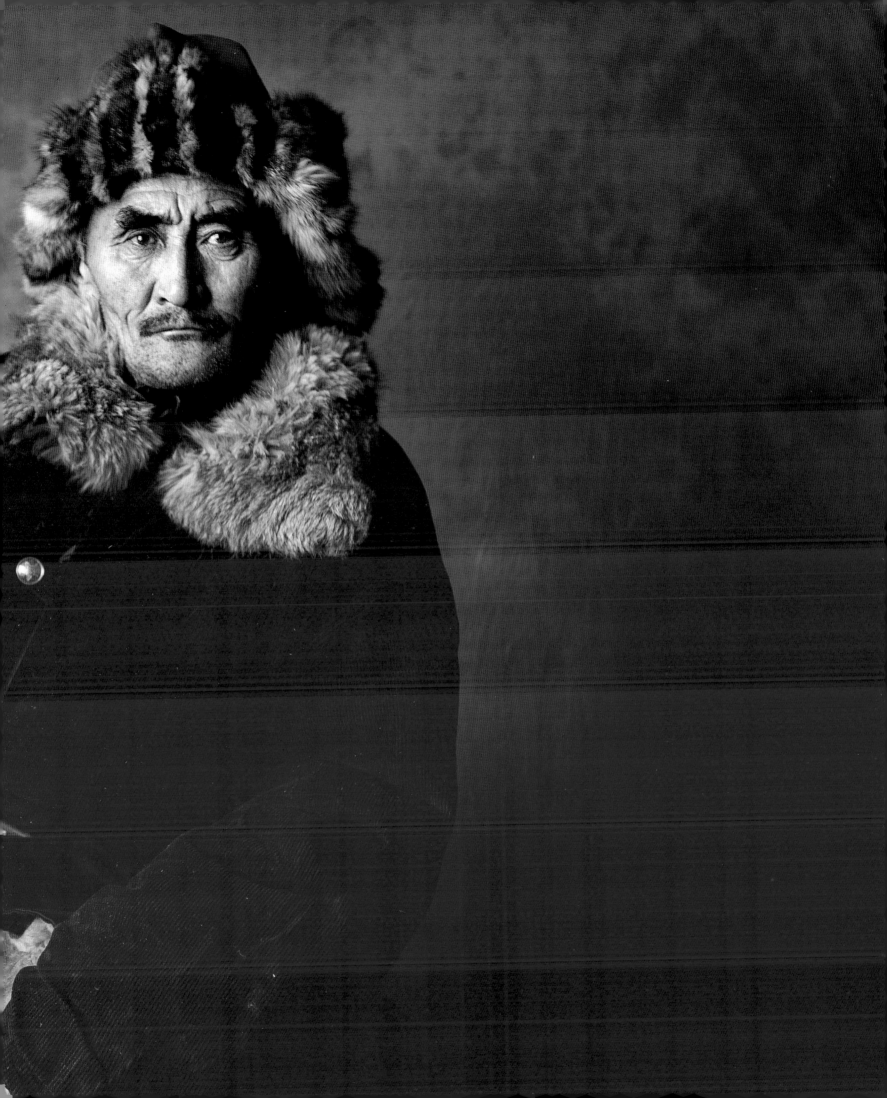

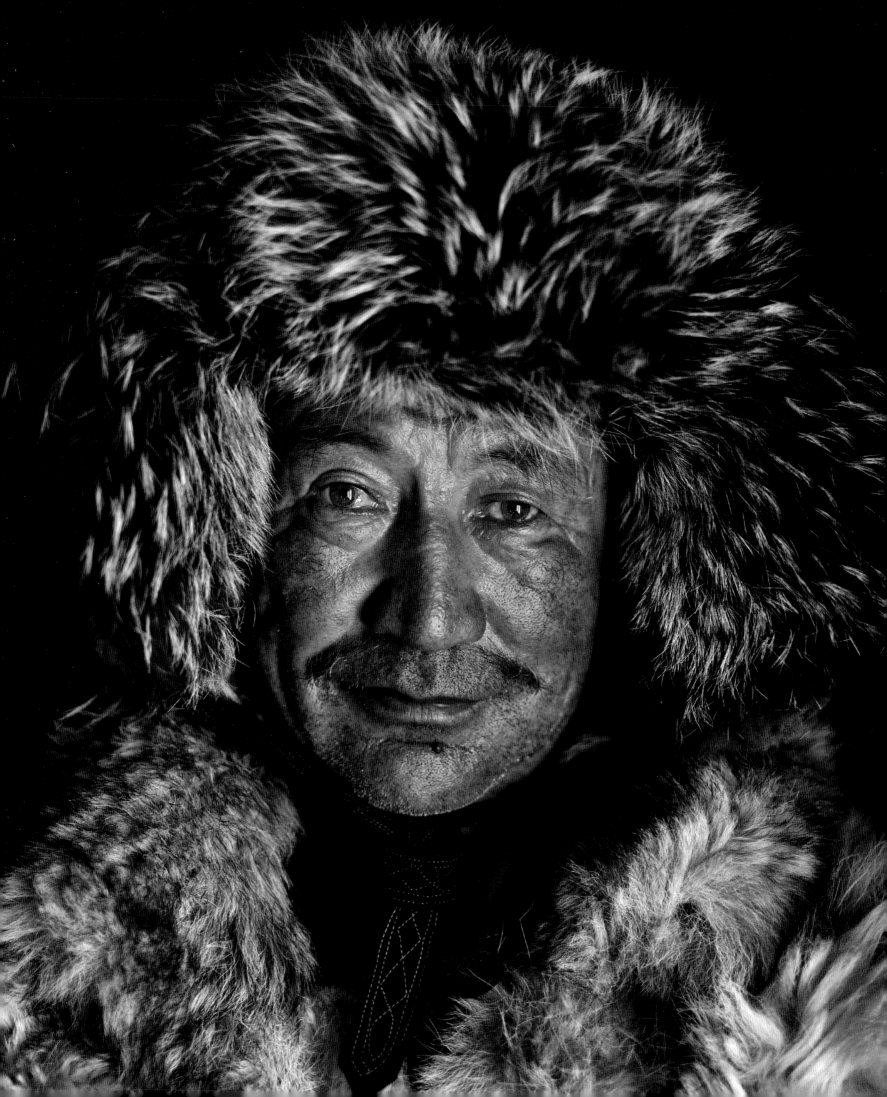

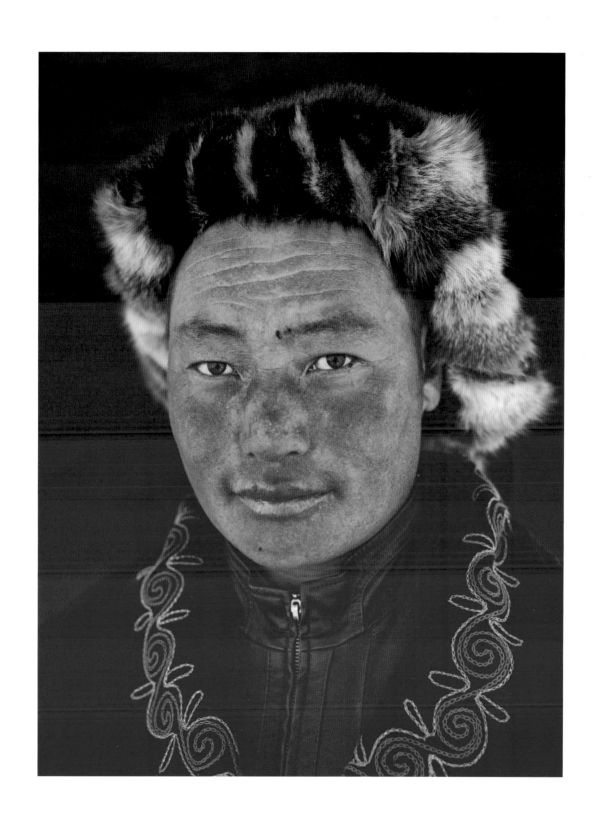

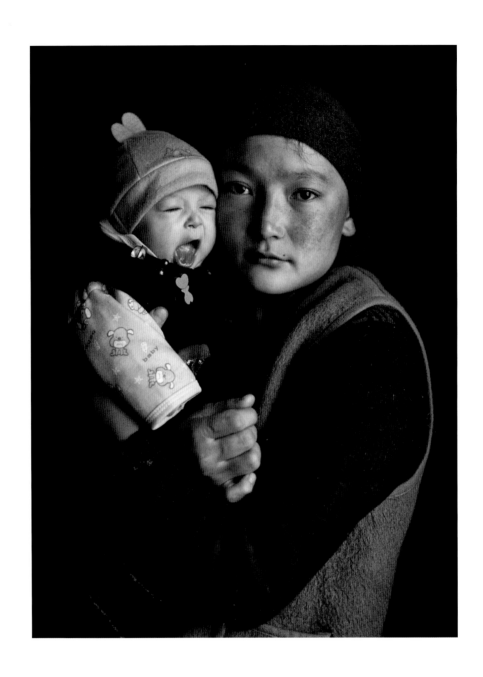

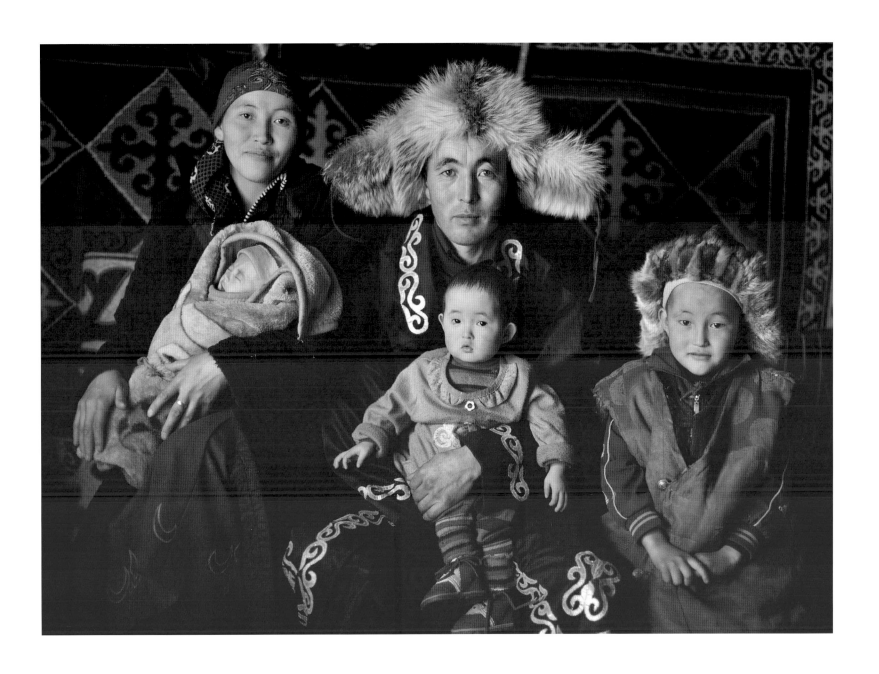

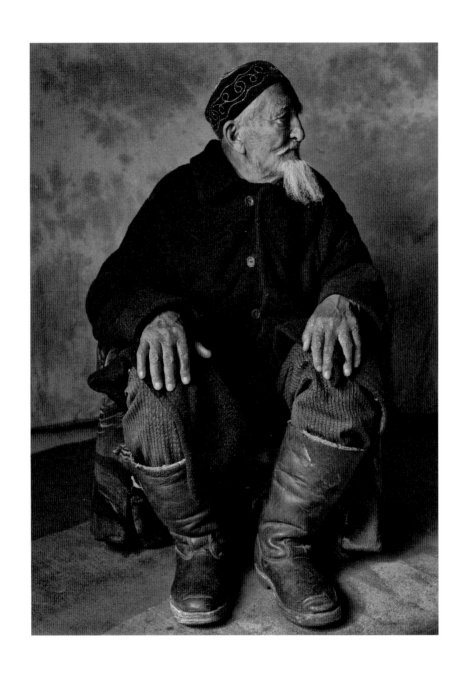

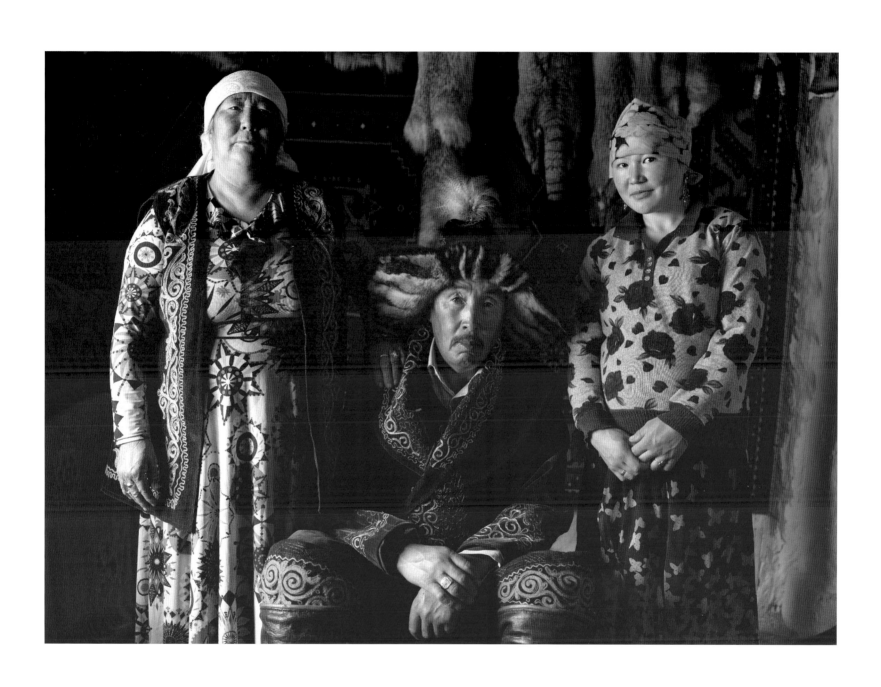

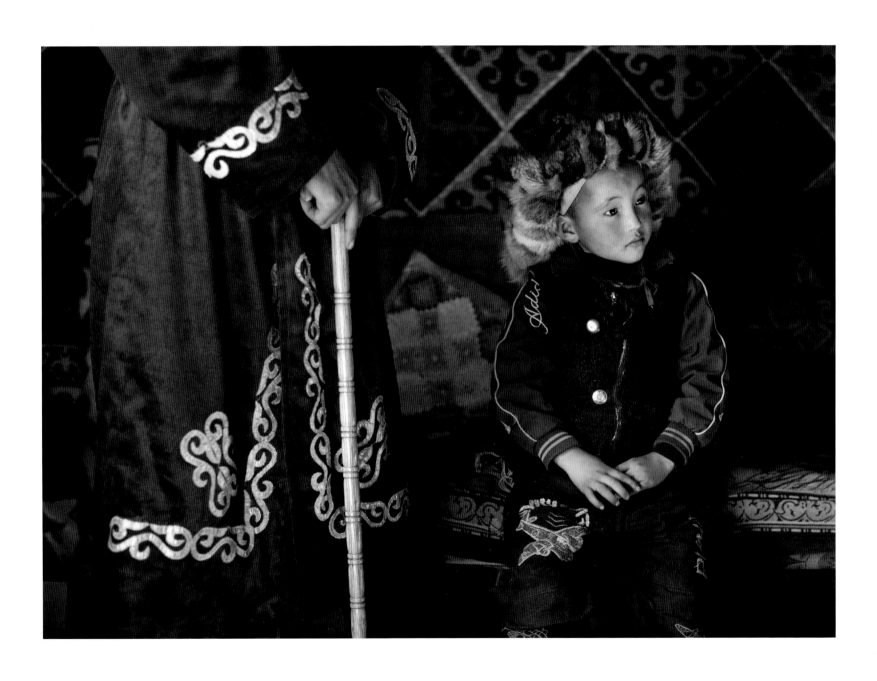

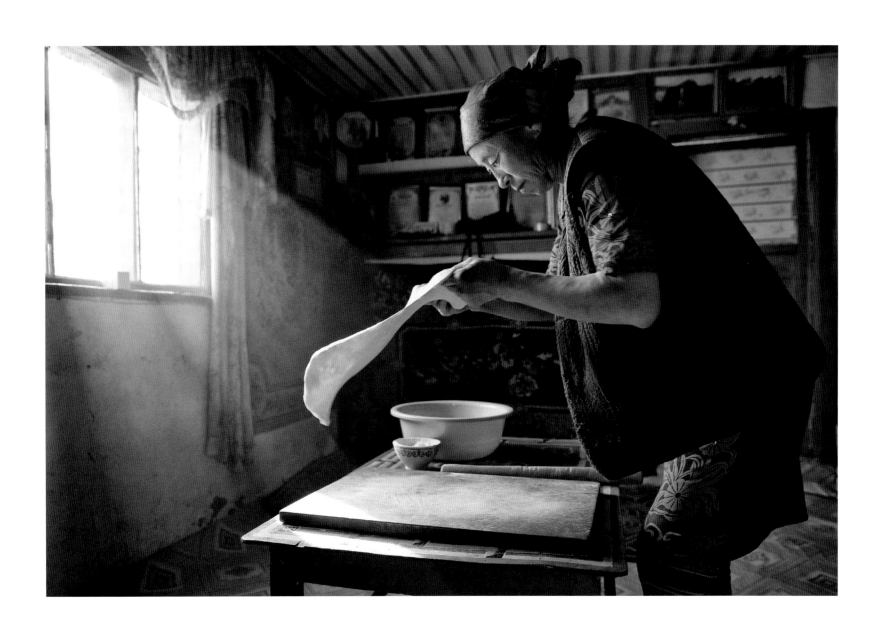

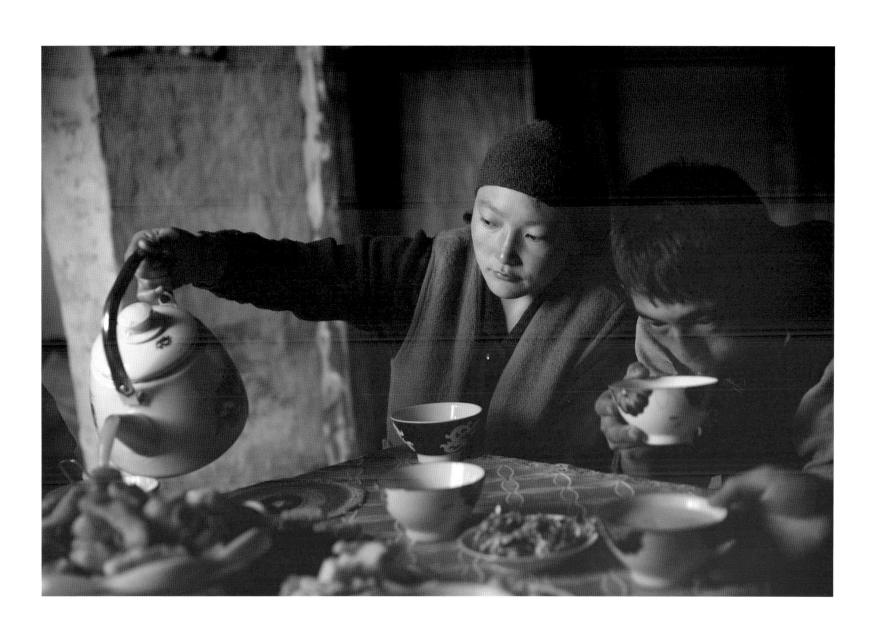

In the warm winter home, away from the cold and the wind, families constantly consume hearty food and warm drinks: dried cheese, chunks of cooked meat and an endless supply of hot yak's milk tea.

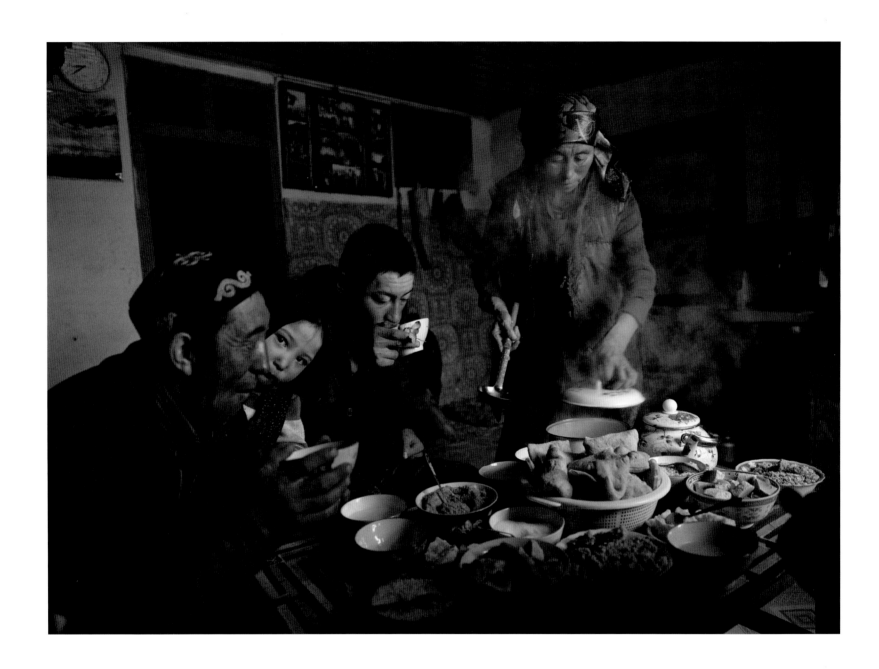

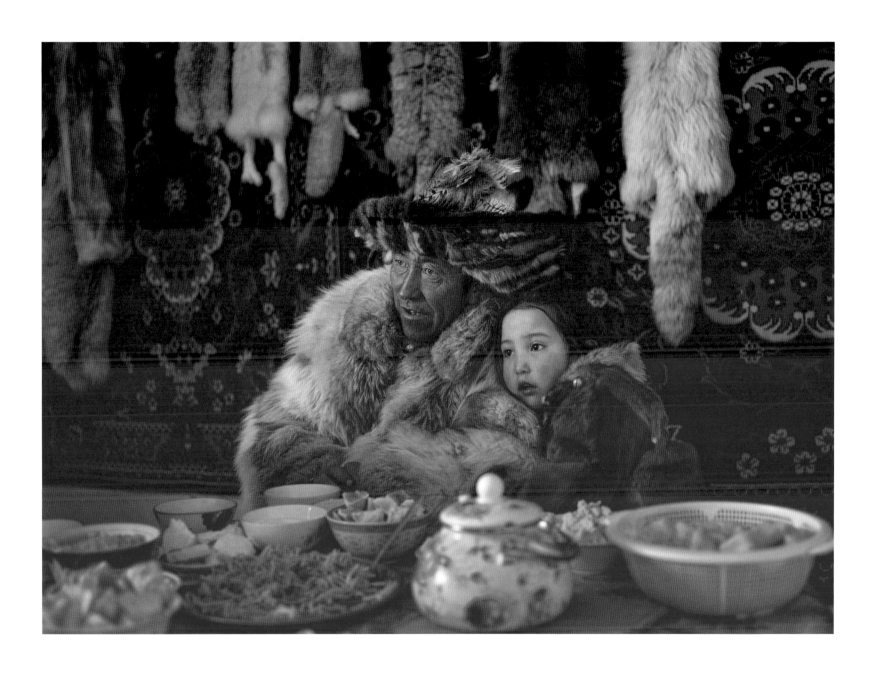

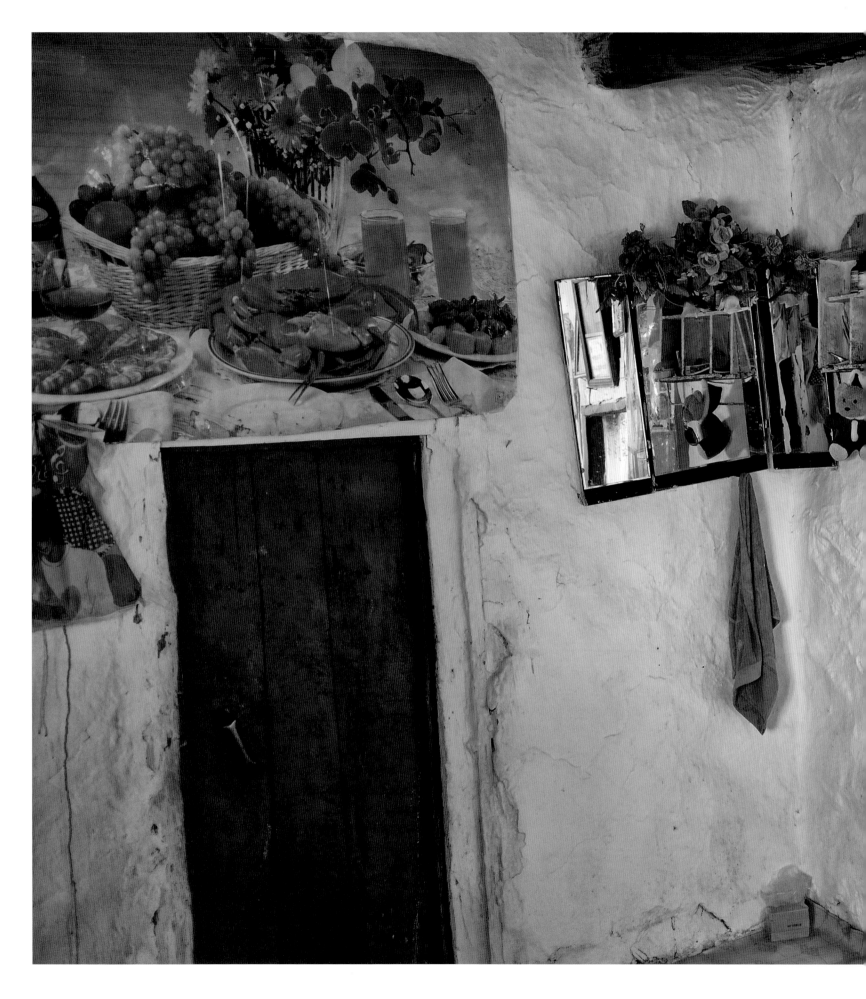

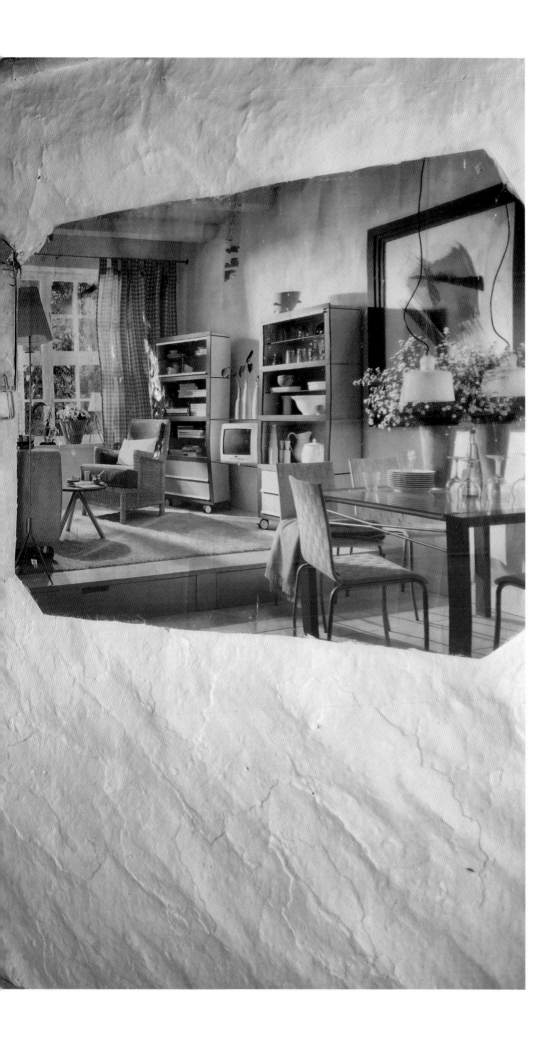

Posters on the wall of a winter home show scenes from another world. The Kazakh family had never eaten the grapes or seafood shown, and were curious to know what they taste like.

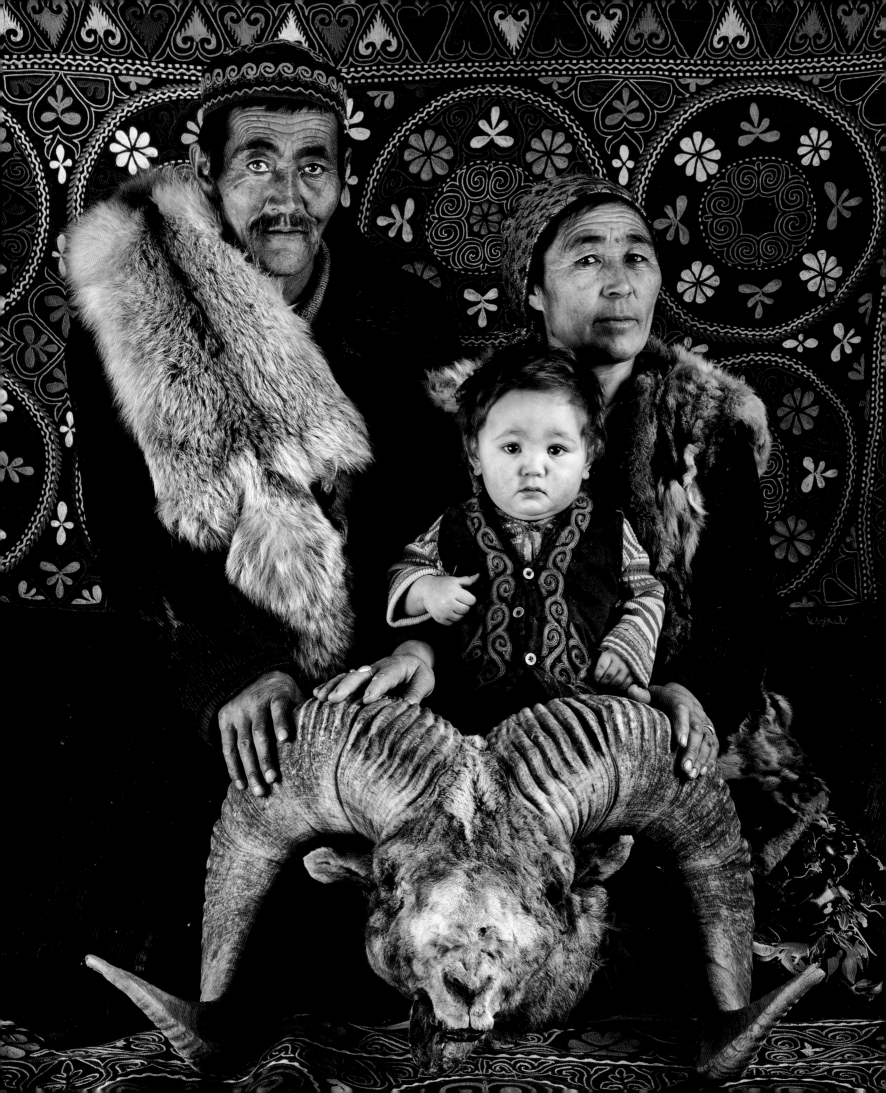

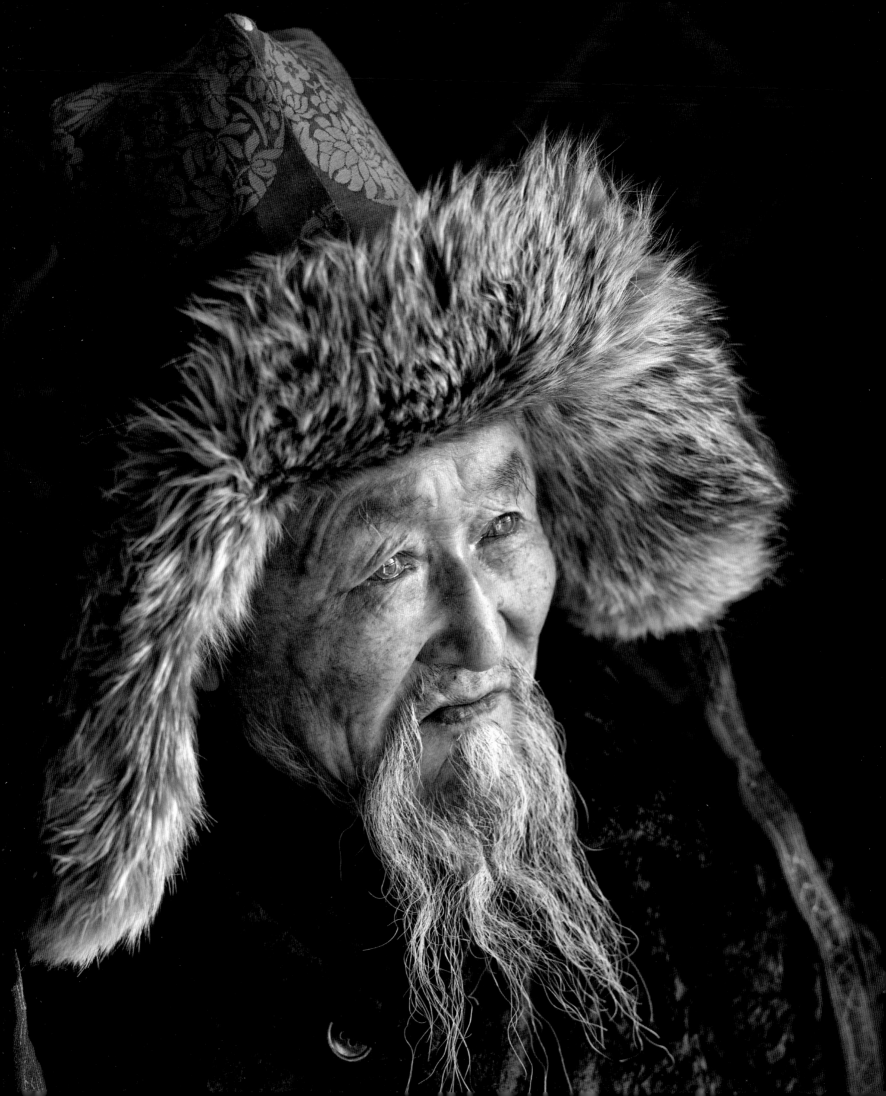

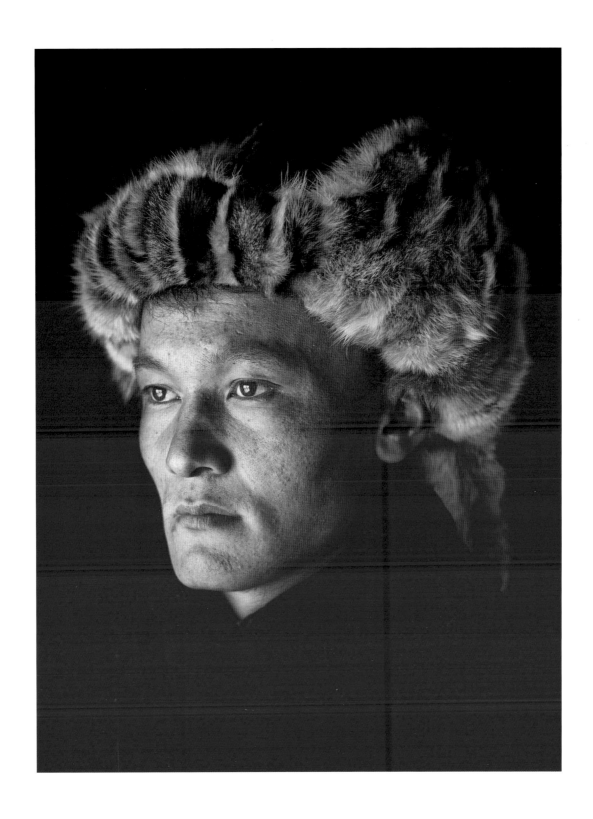

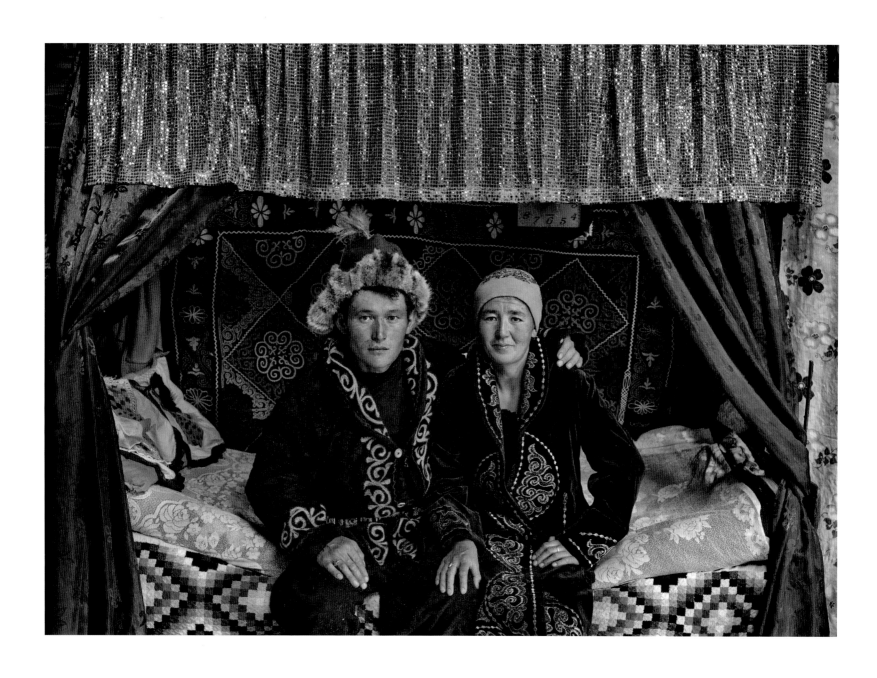

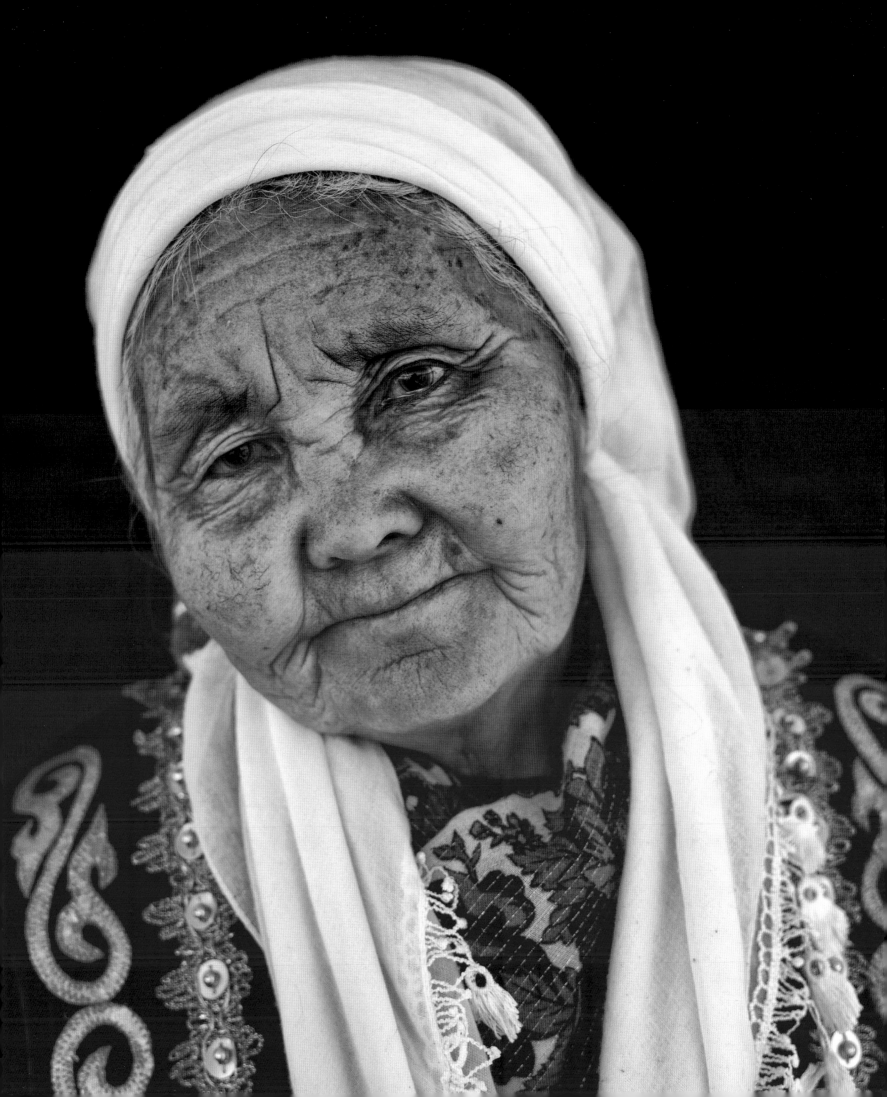

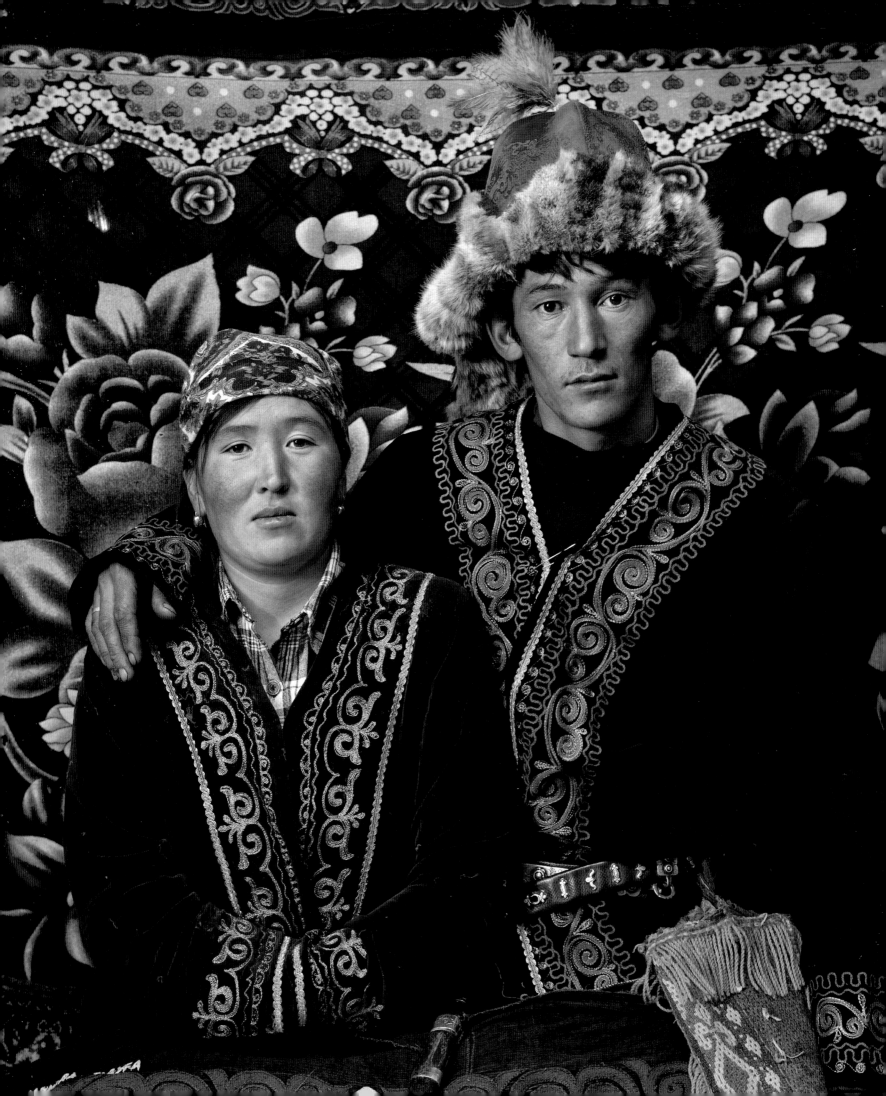

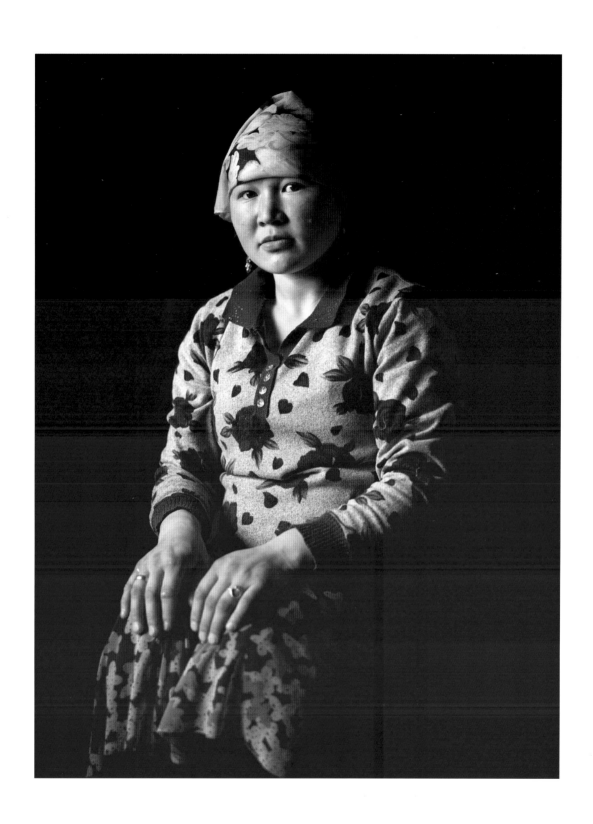

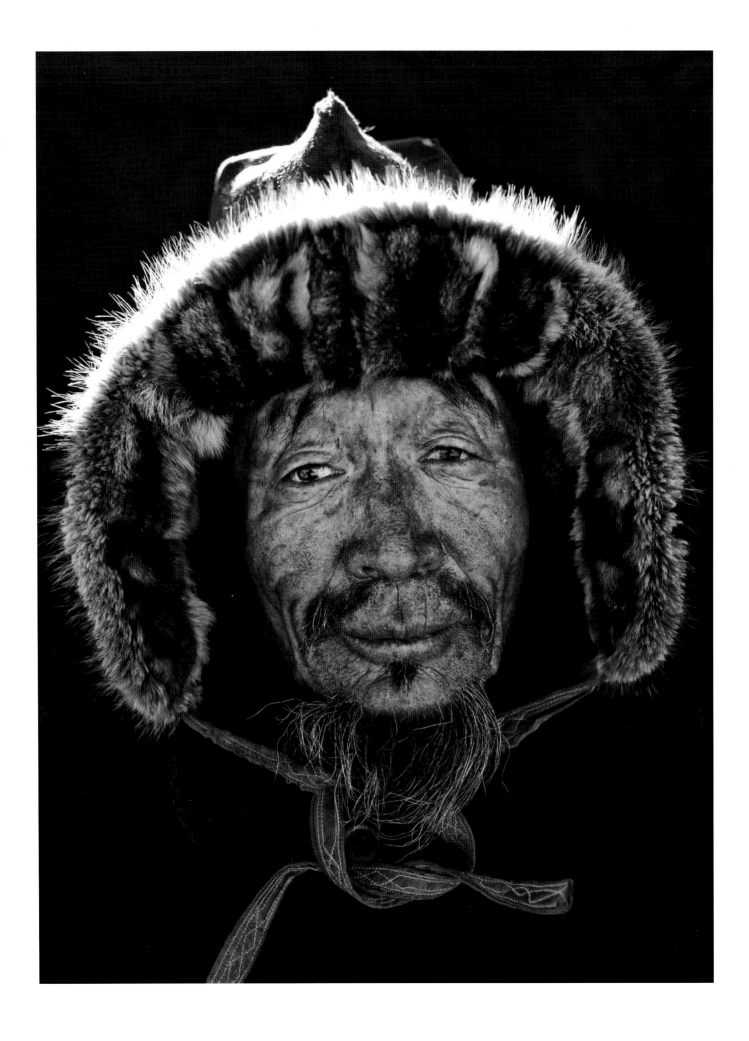

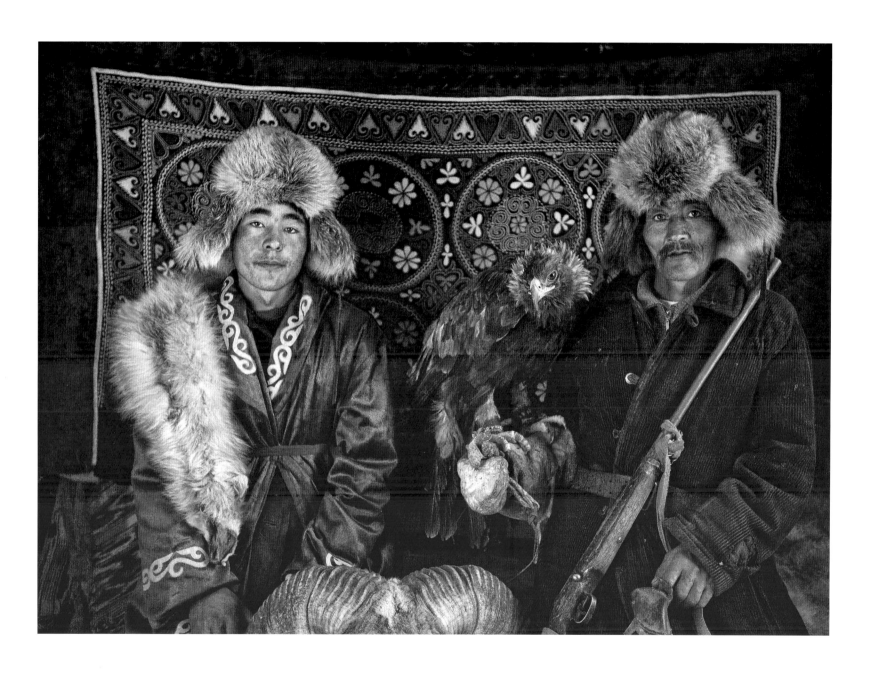

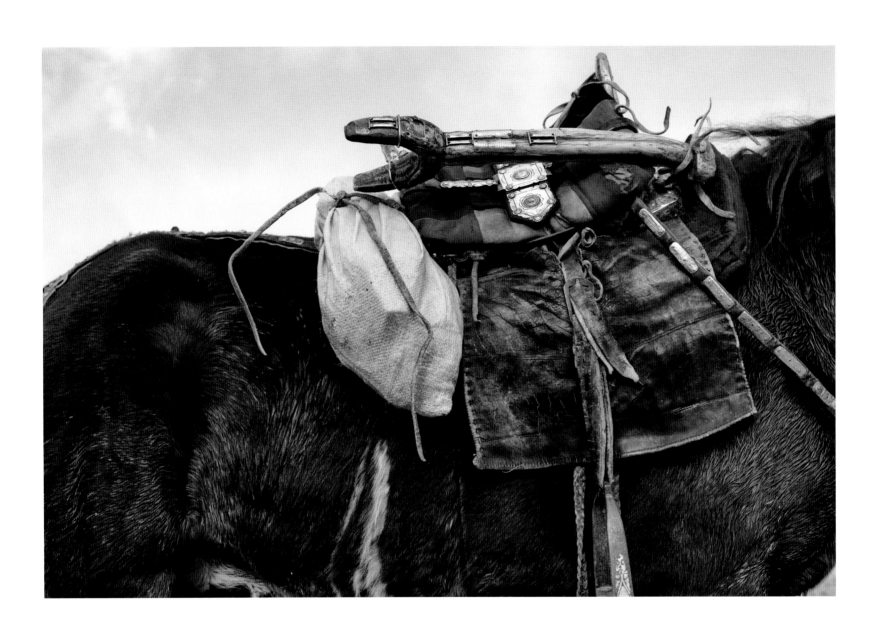

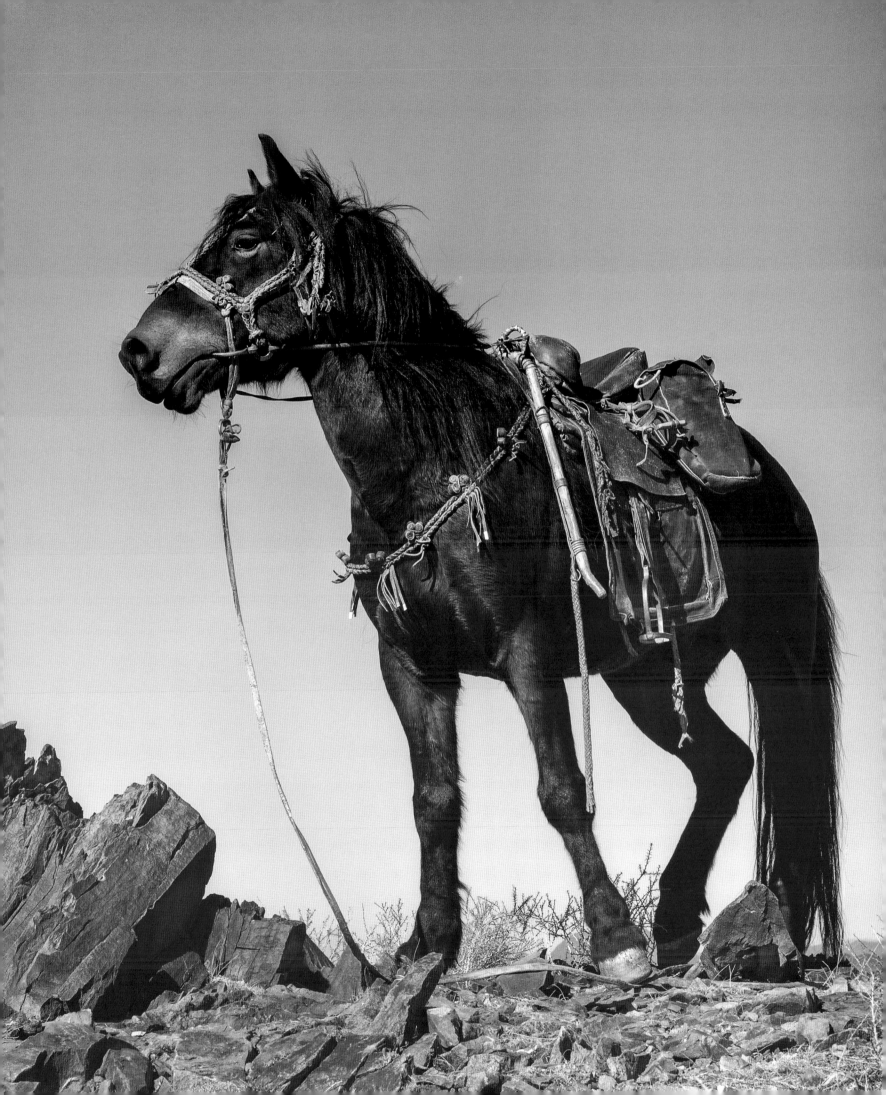

A group of young Kazakh men play *ulak tartysh*, a traditional game in which teams battle for control of a goat carcass, in a sometimes brutal test of their horsemanship.

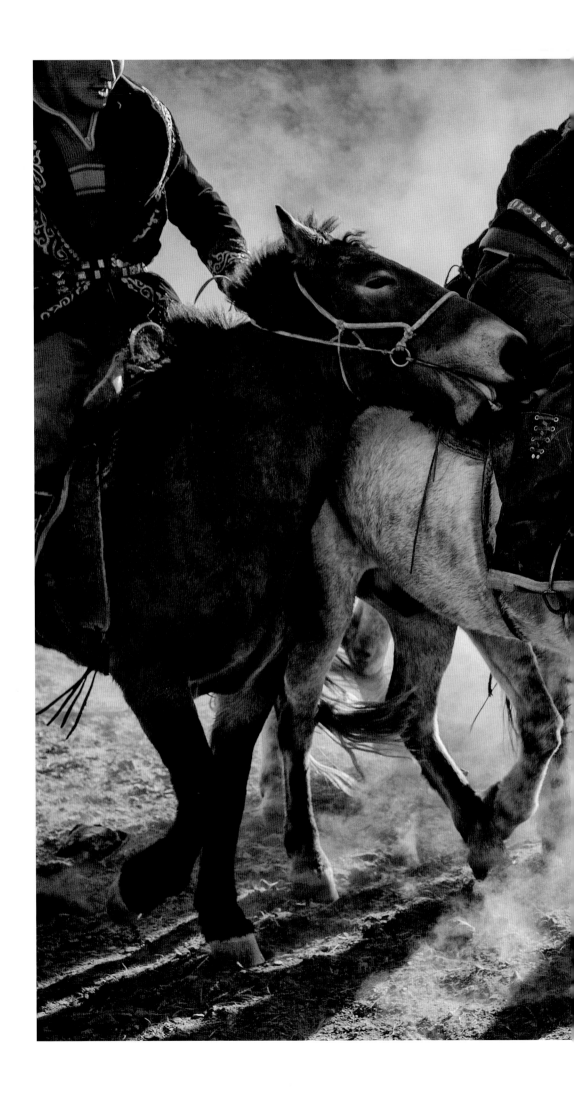

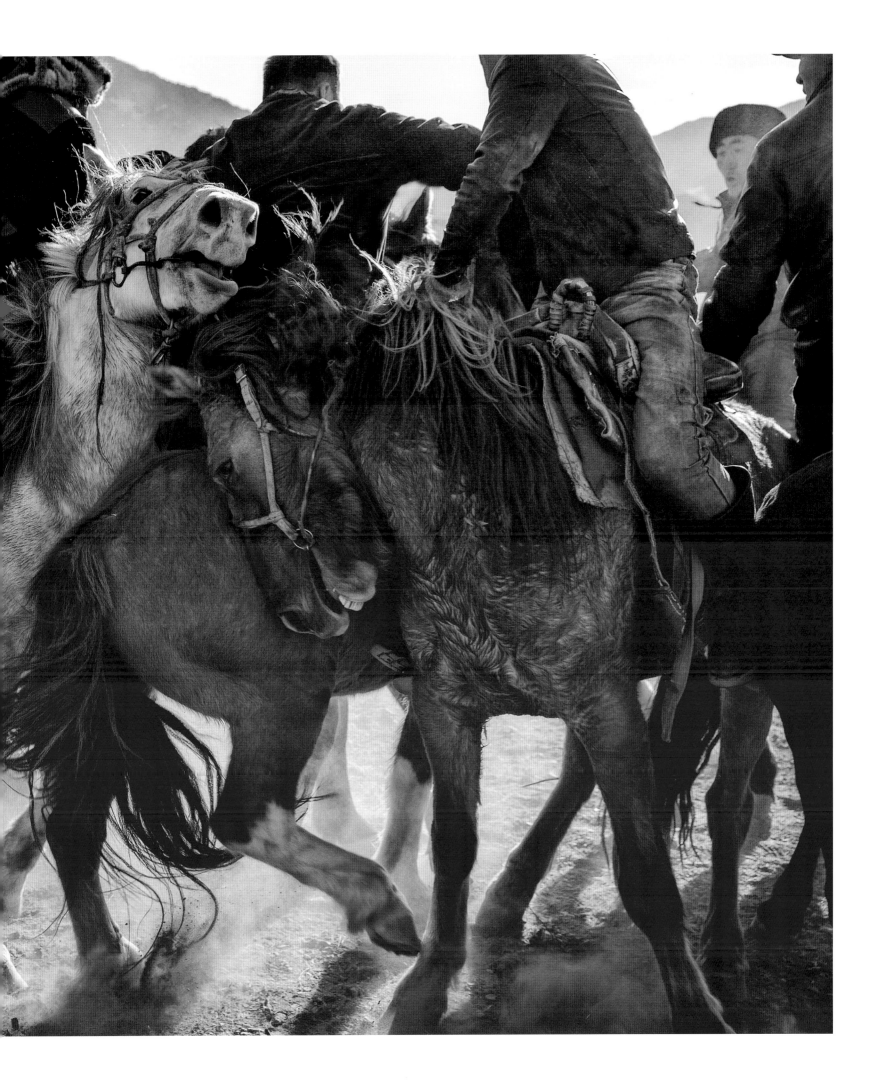

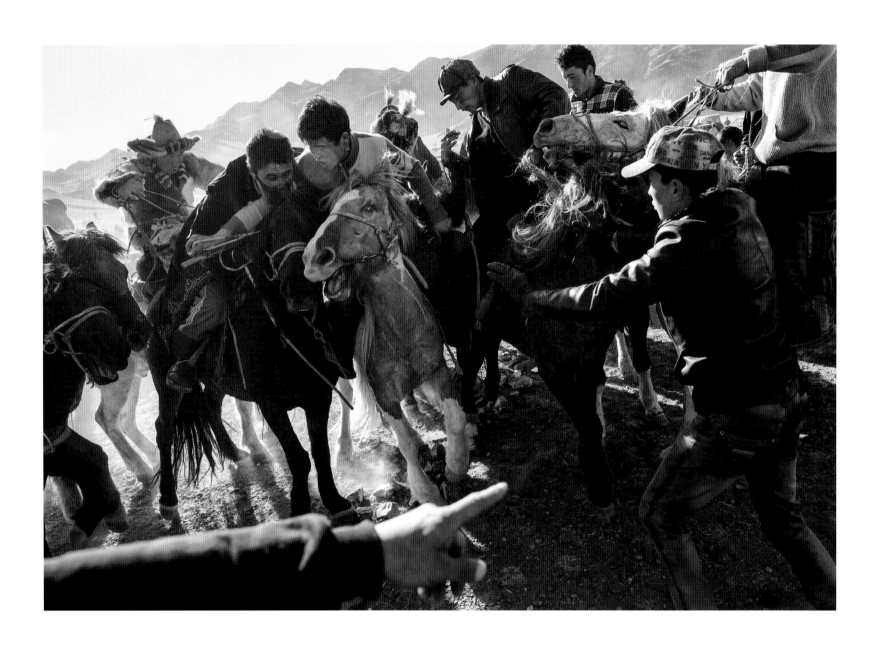

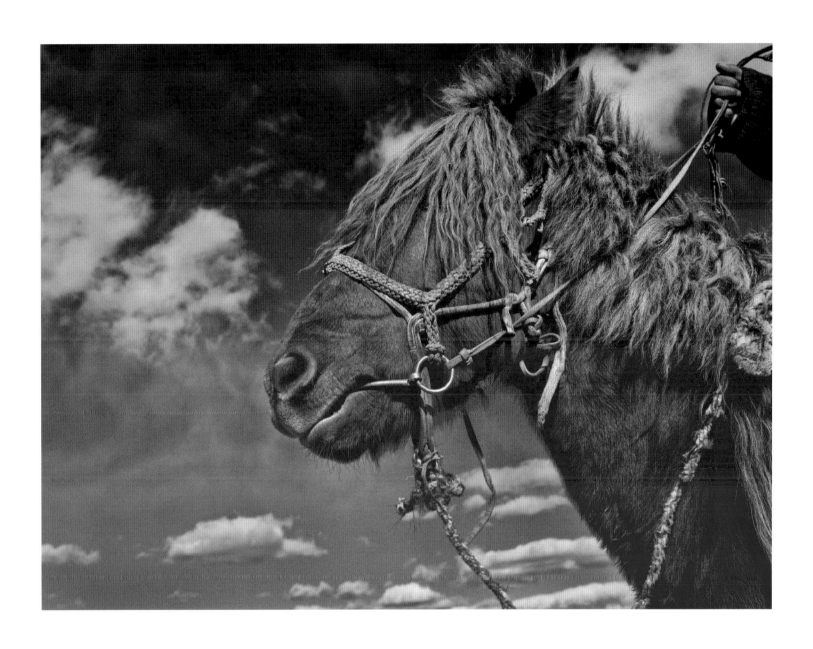

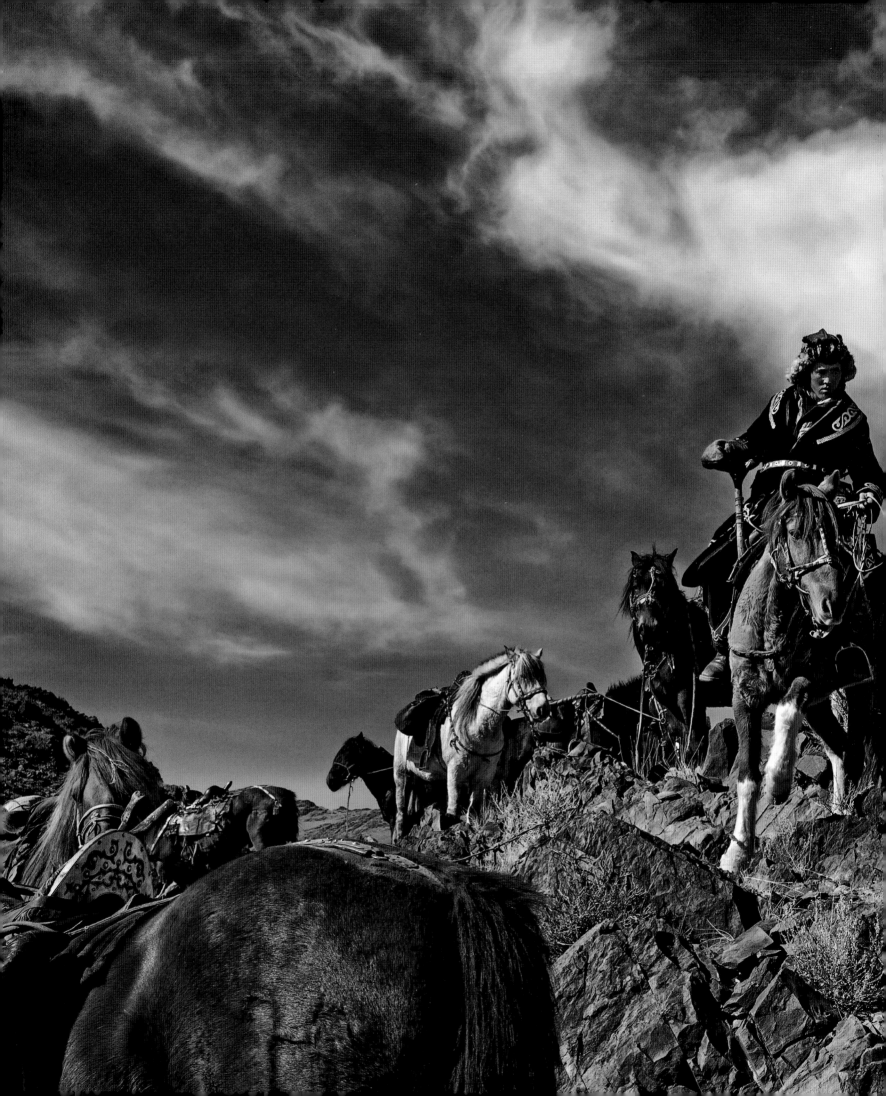

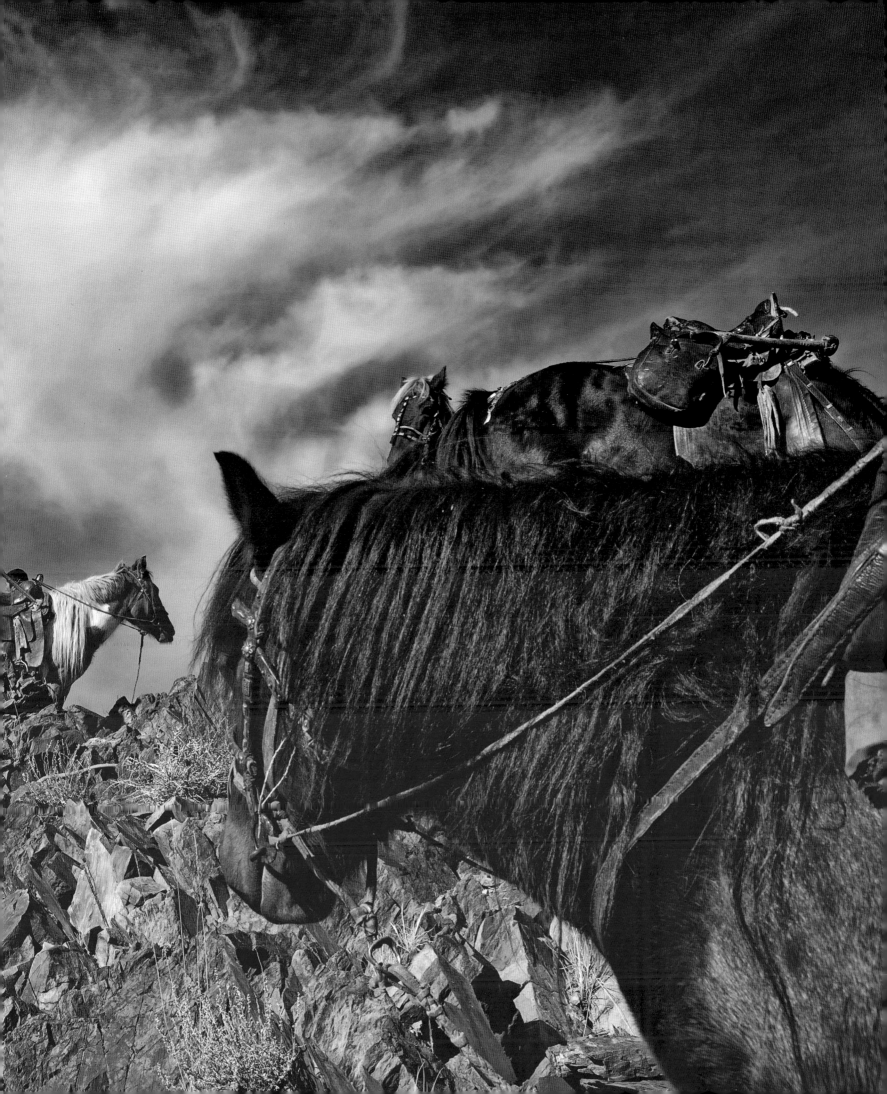

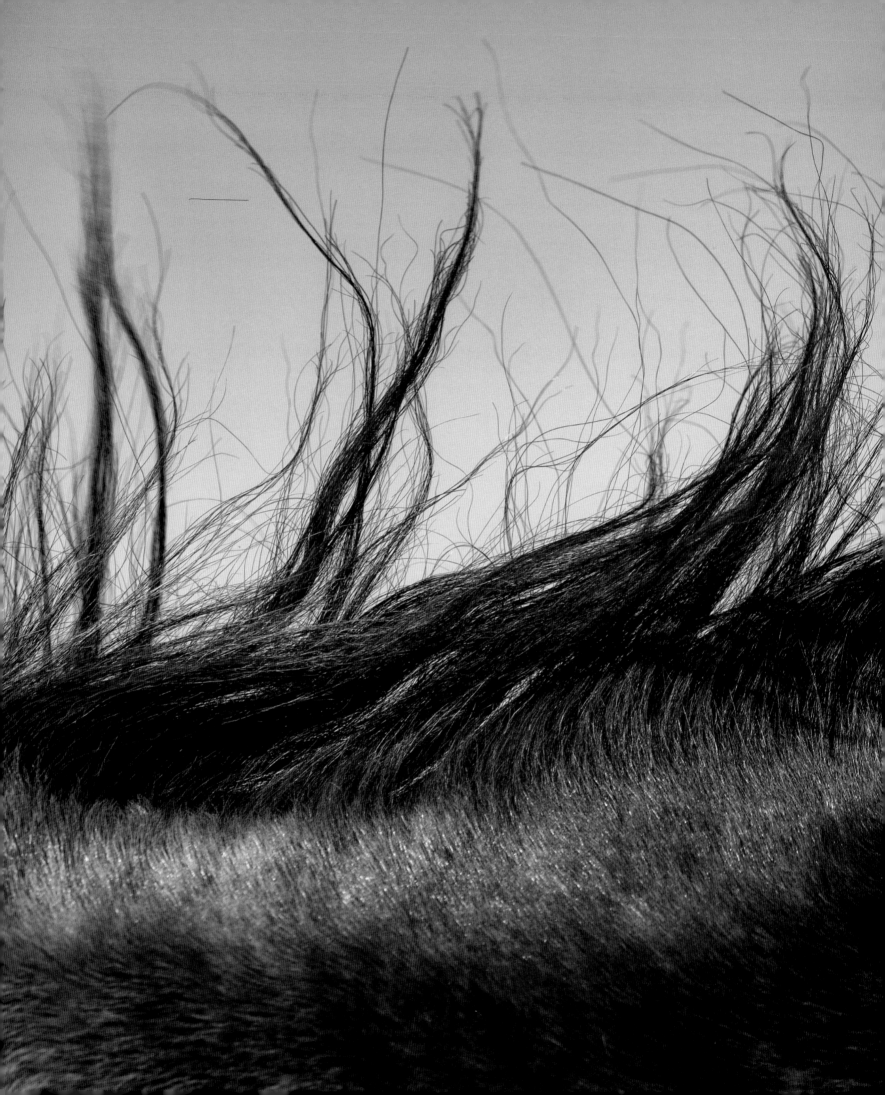

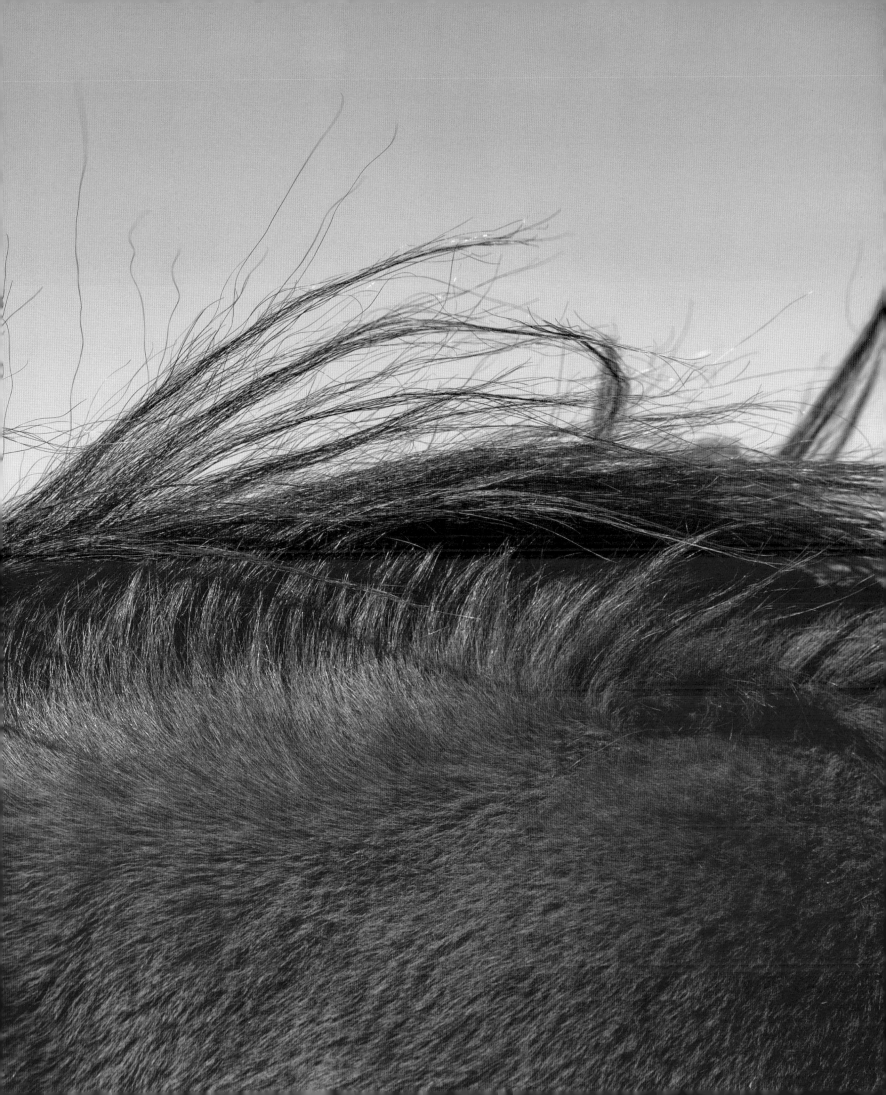

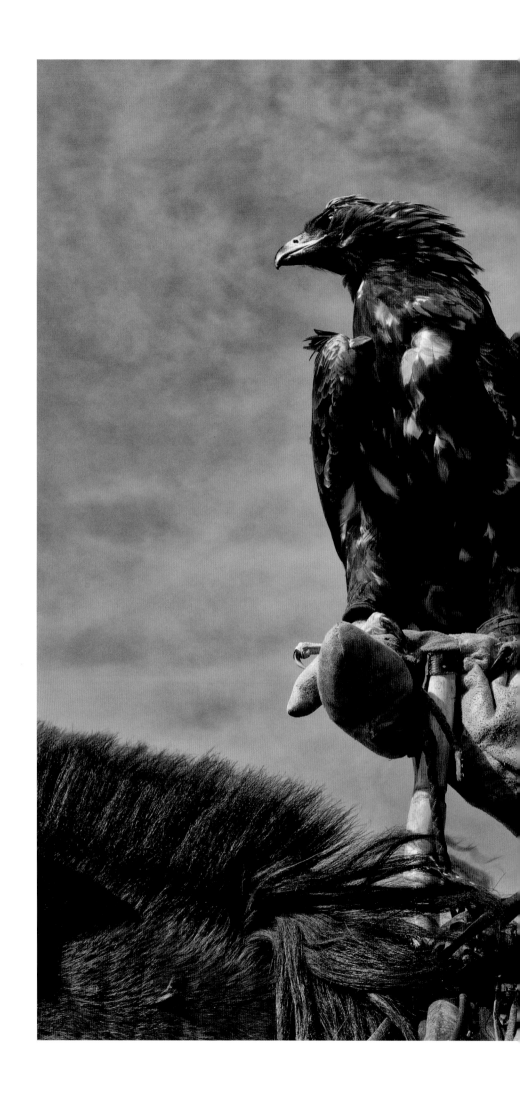

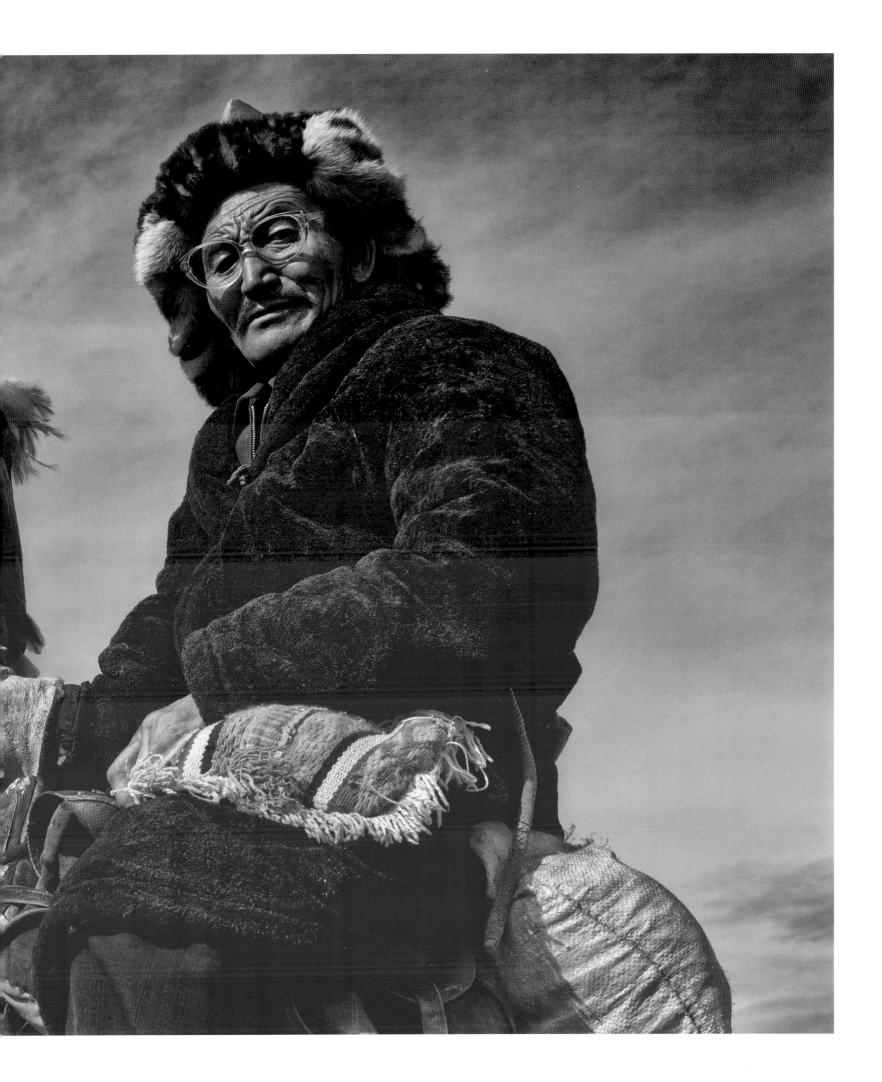

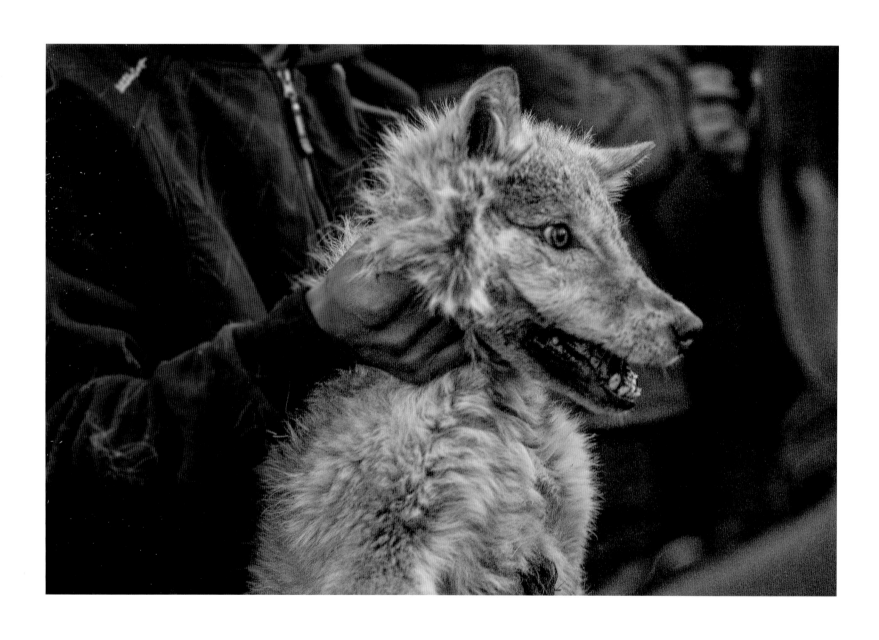

A red fox, killed in seconds by
a swooping eagle, is strapped
to the back of a horse.

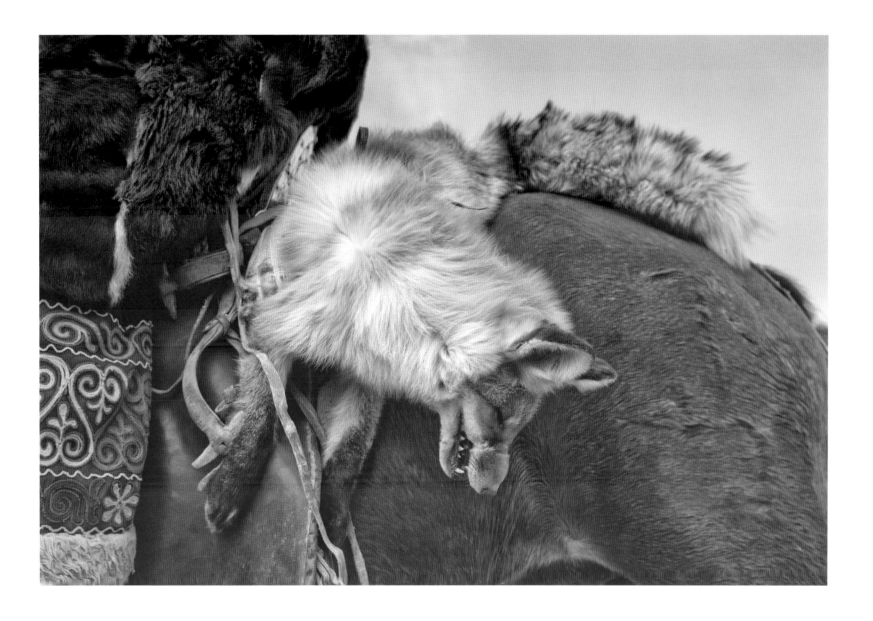

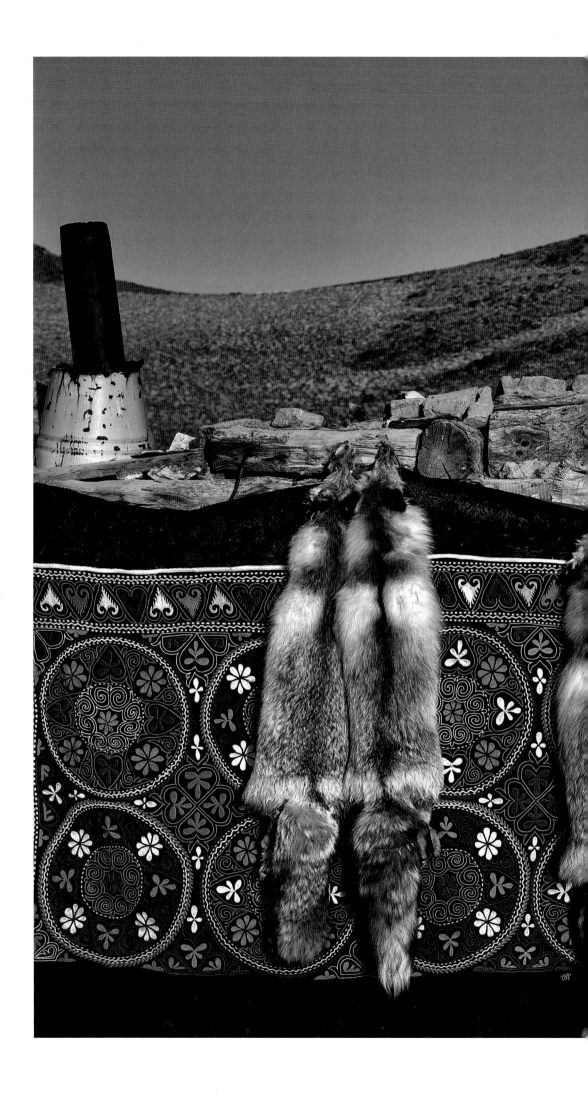

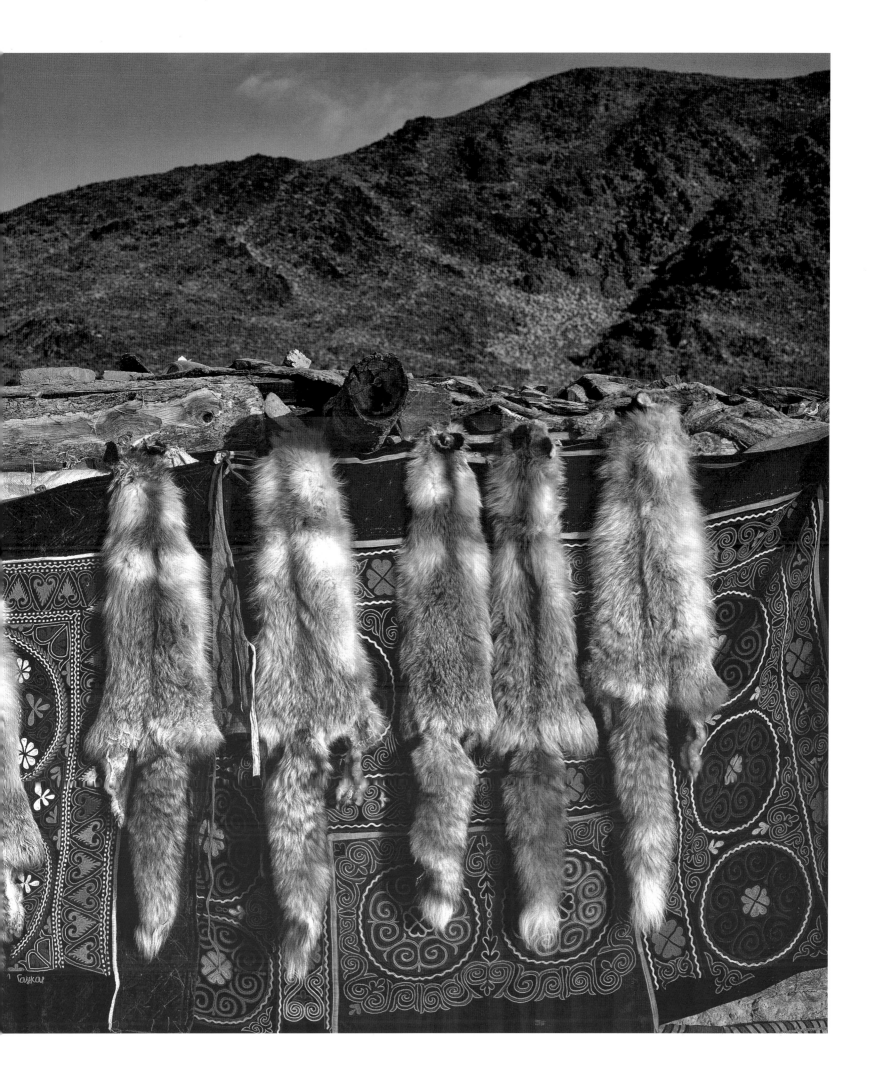

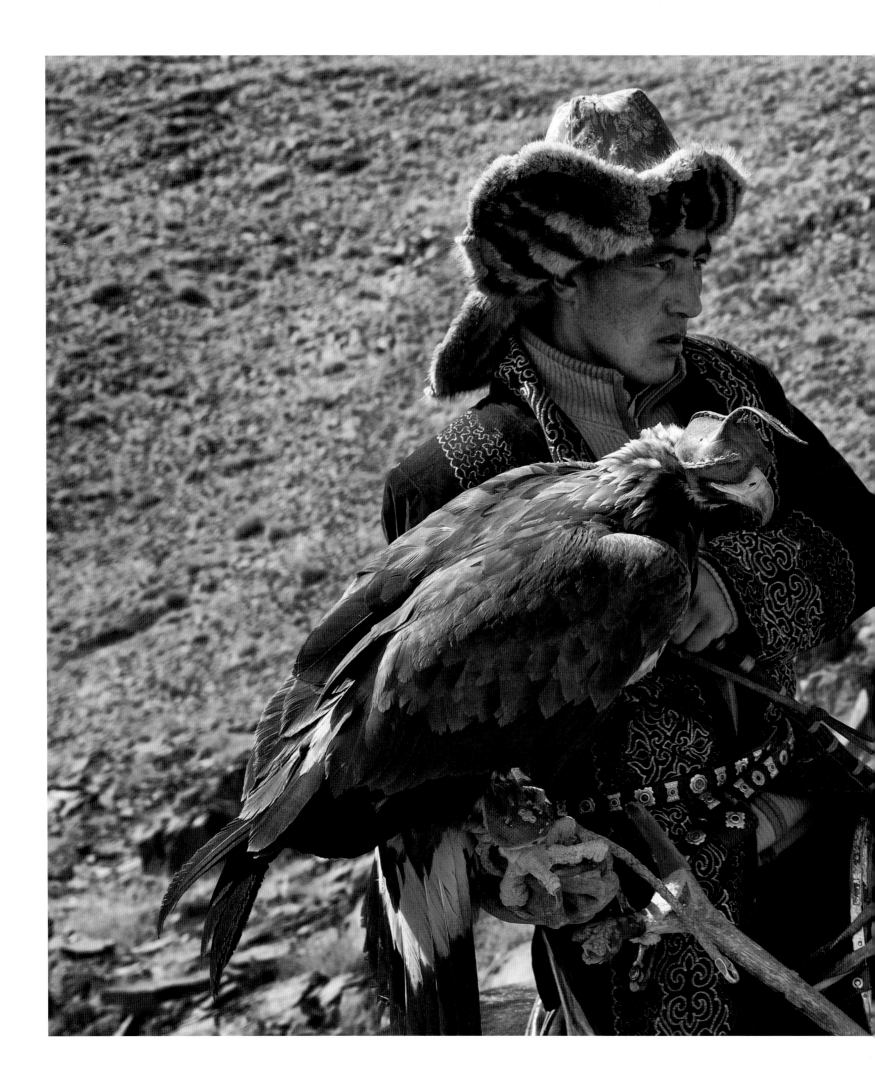

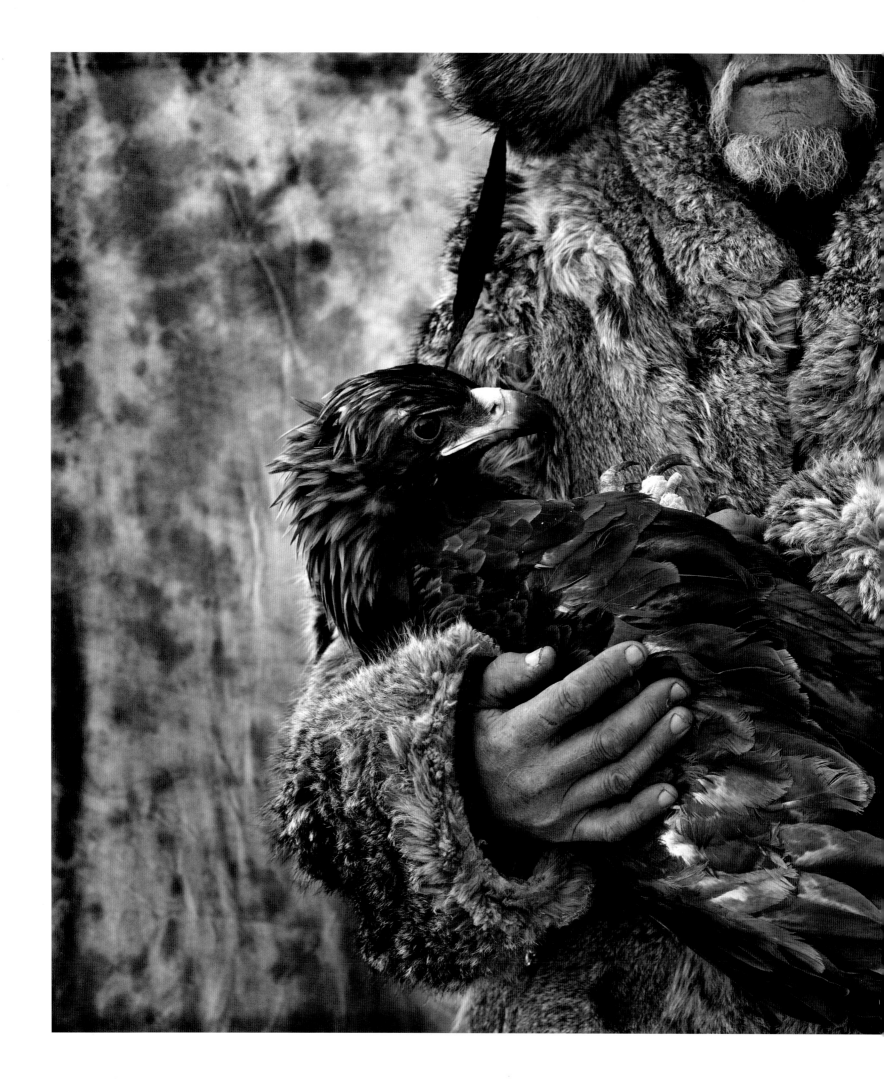

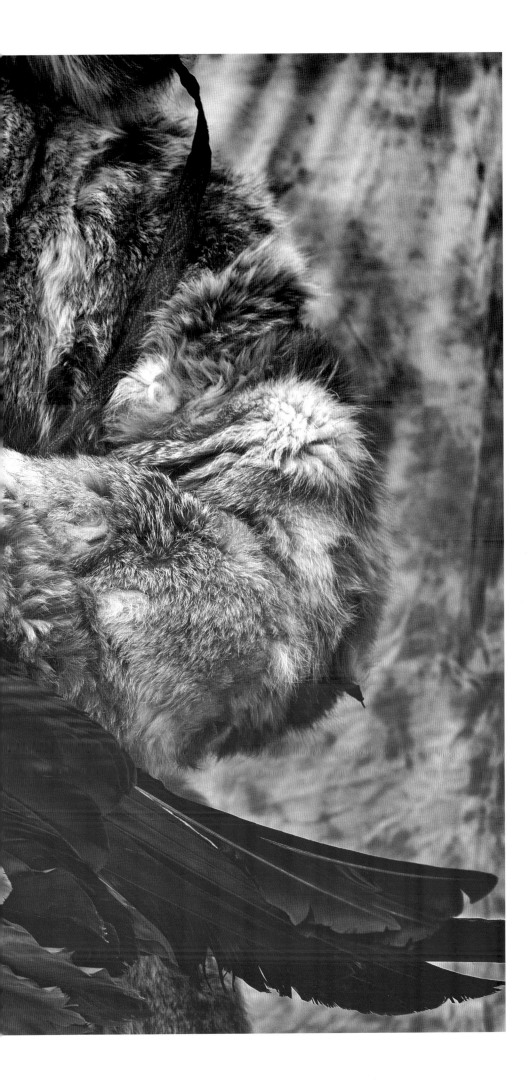

Madina, a 63-year-old wearing a fox-skin coat, cradles his six-year-old eagle in his arms. 'They love to be carried in such a way. It makes them feel loved and relaxes them, just like a baby', he told me.

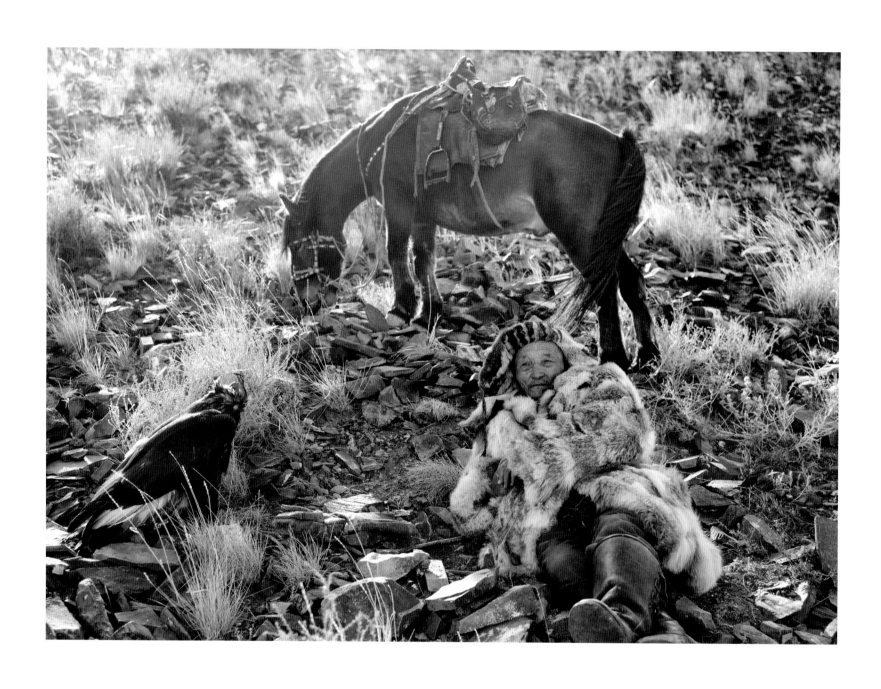

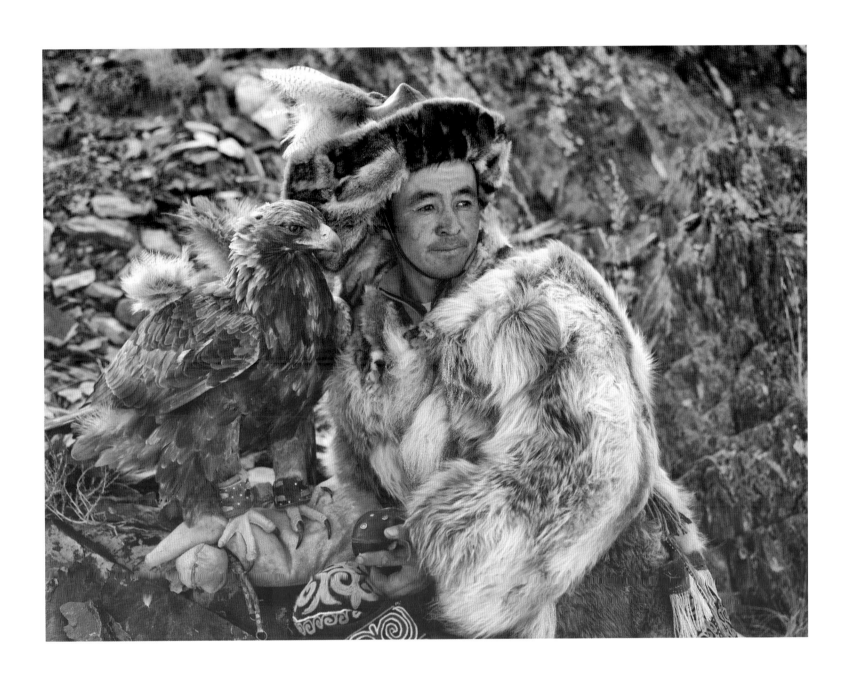

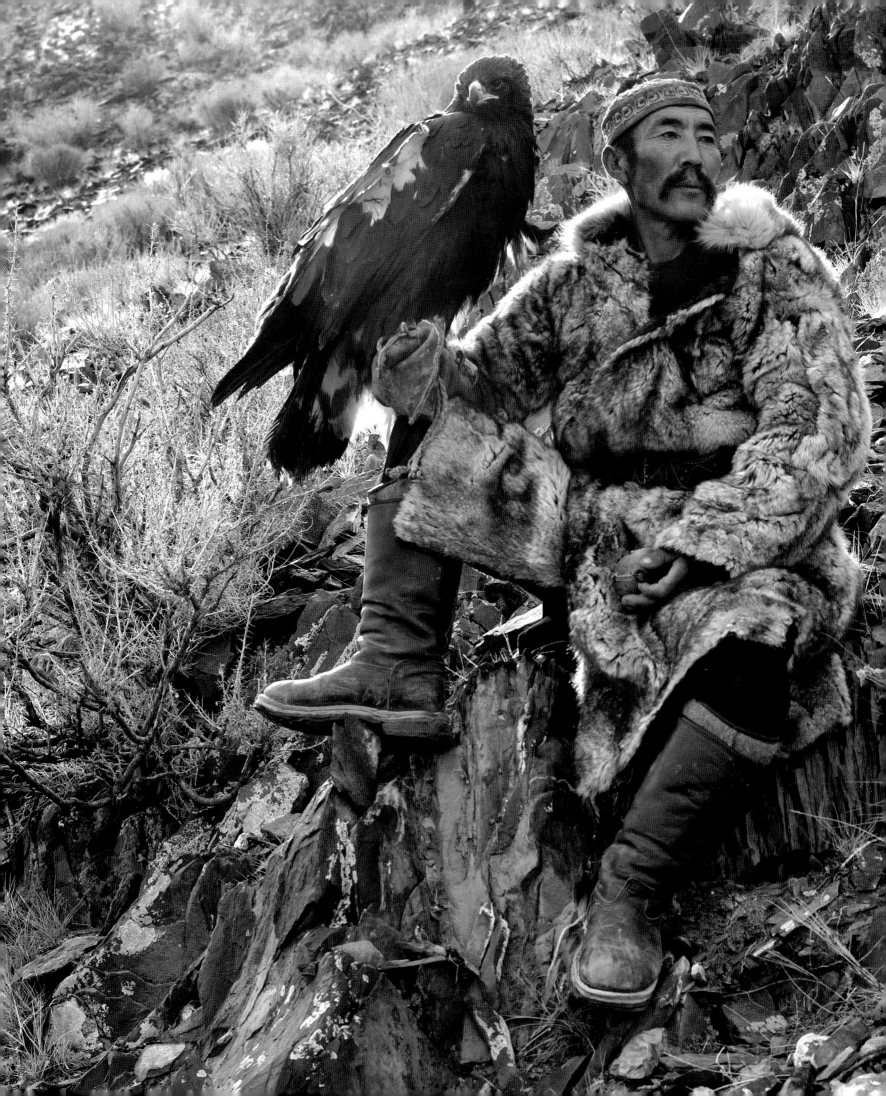

In the depths of winter it becomes too cold even for the eagles, so they are swaddled in pieces of leather and hand-woven carpet. The hunters say that swaddling keeps the birds relaxed, warm and fresh for the hunt ahead.

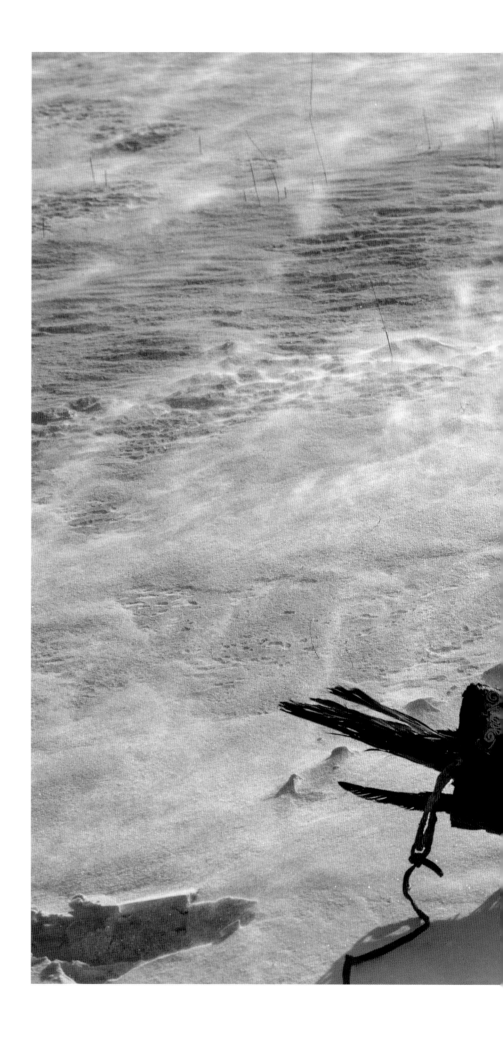

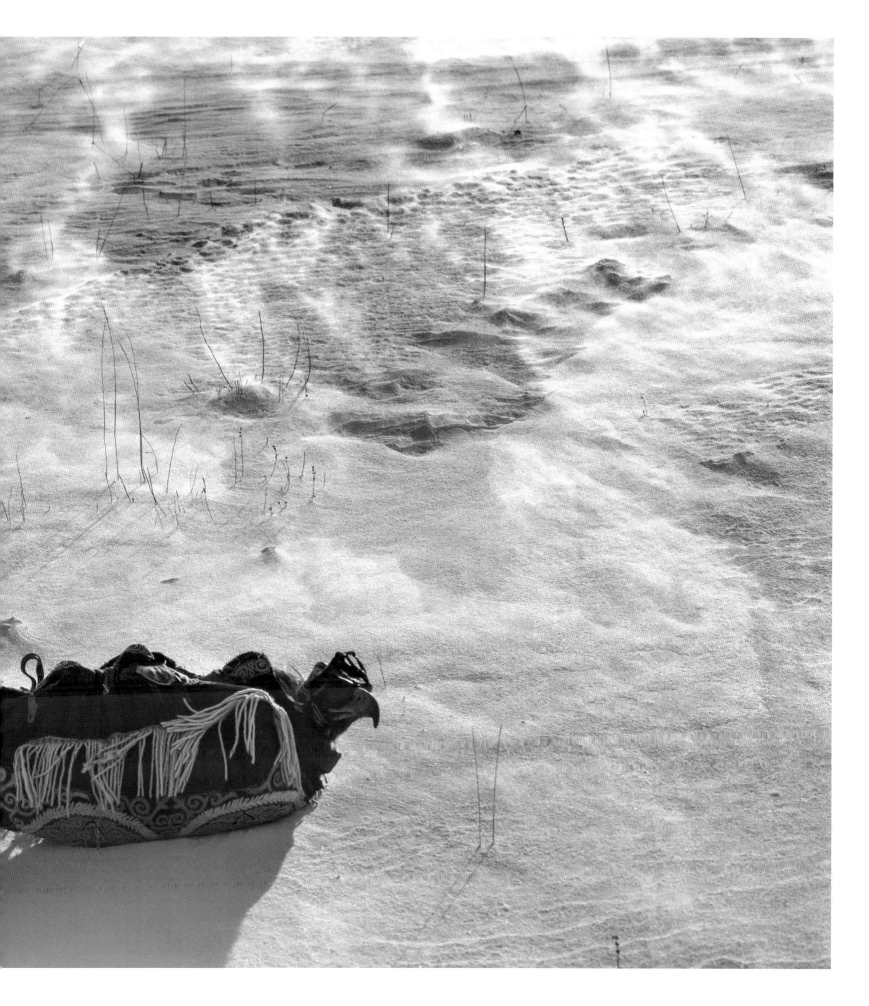

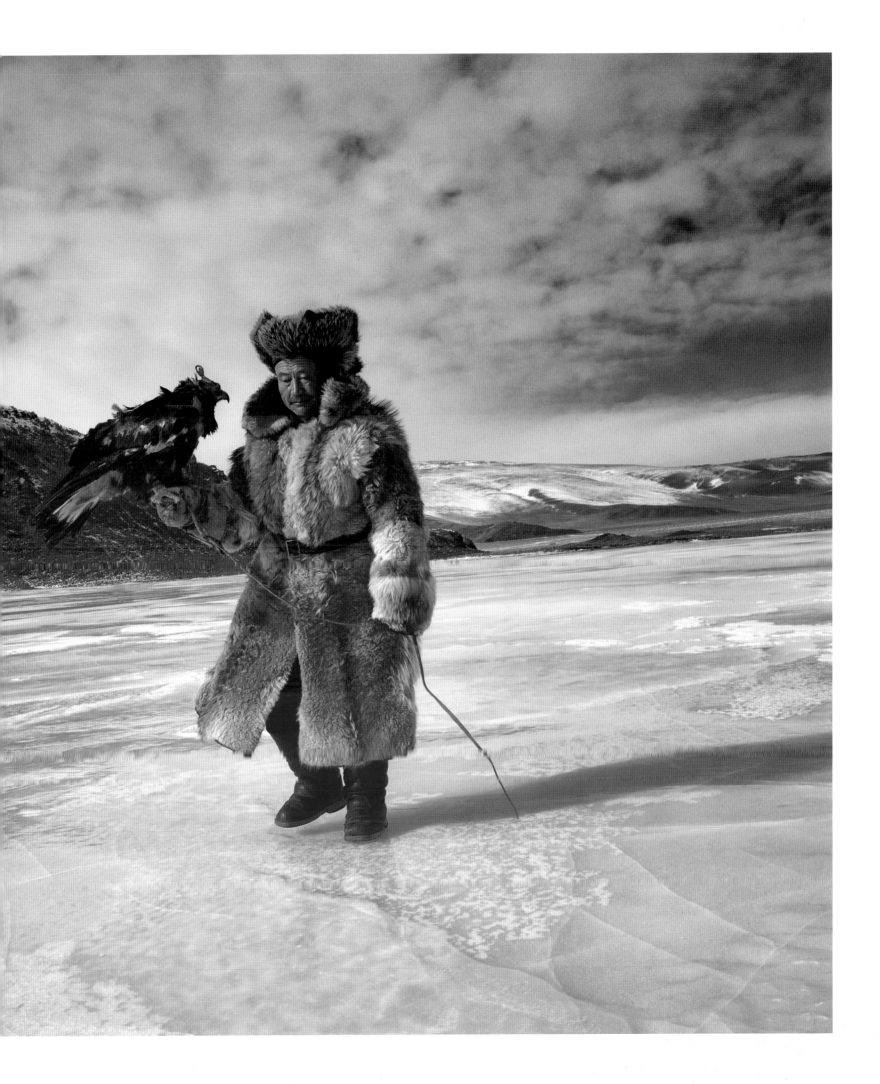

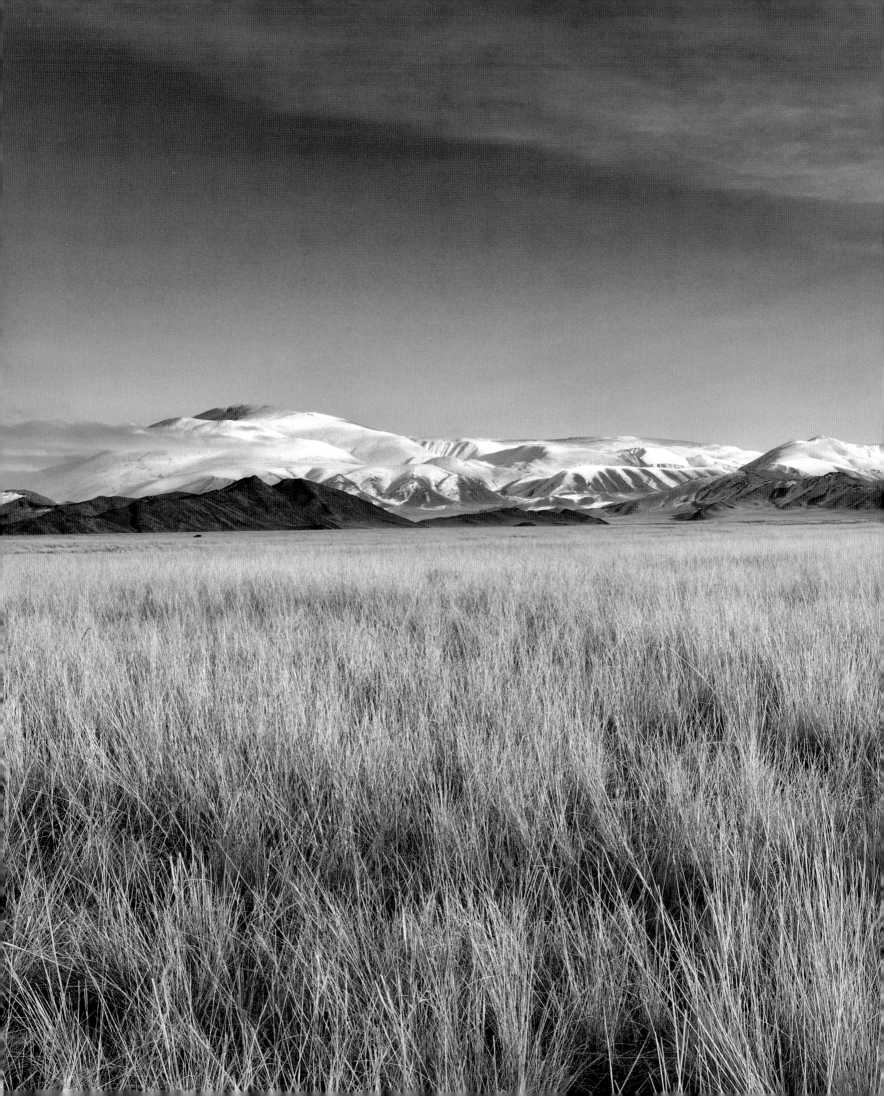

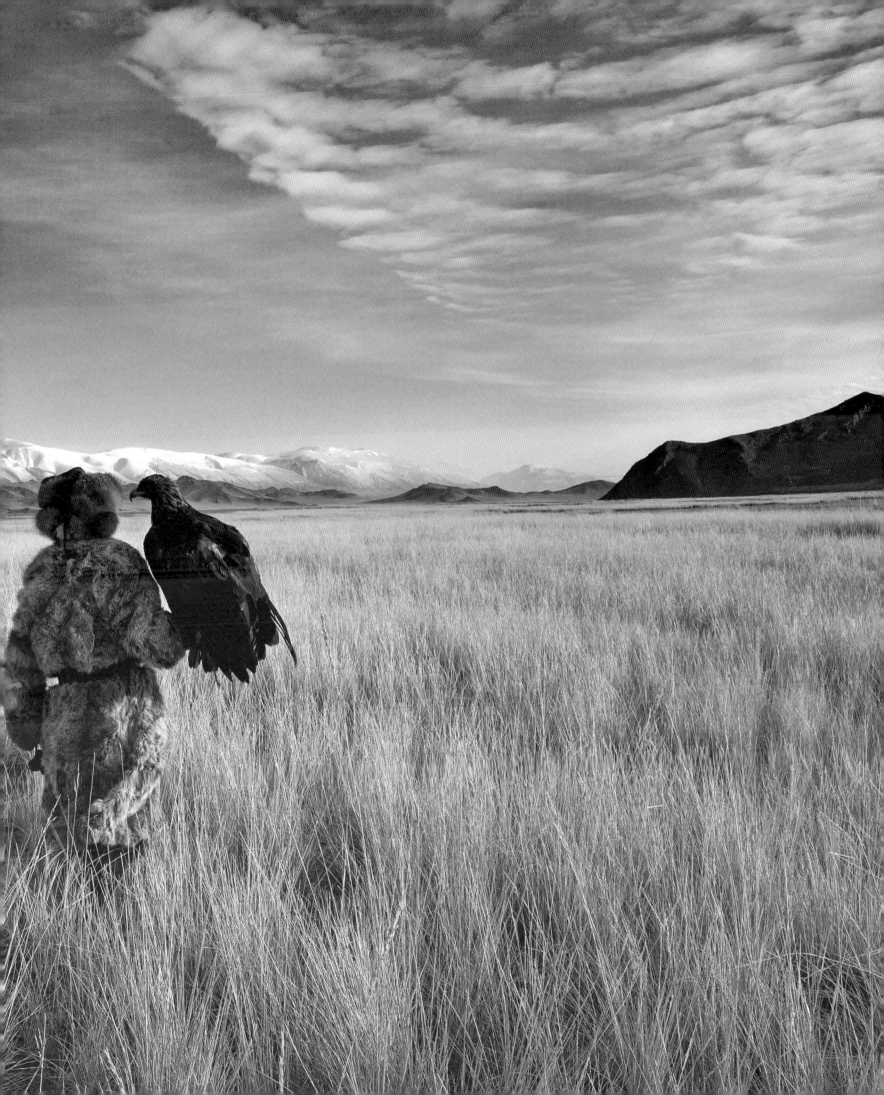

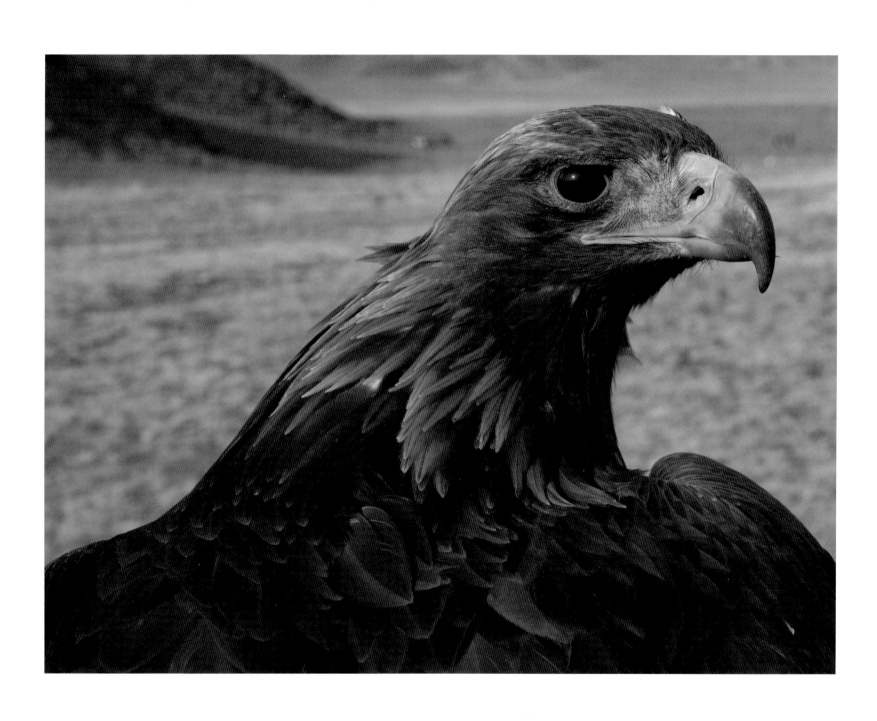

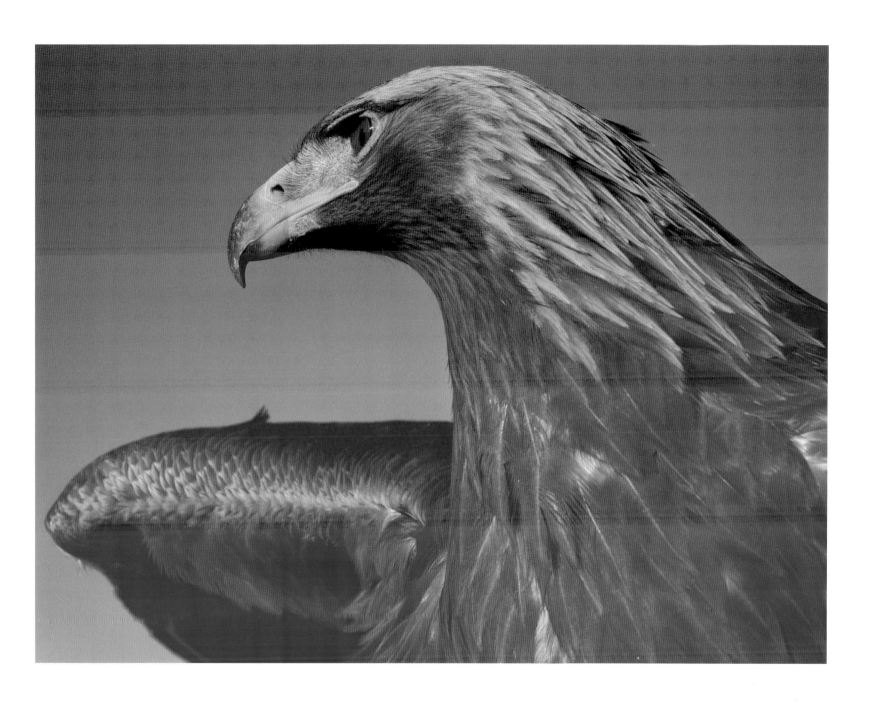

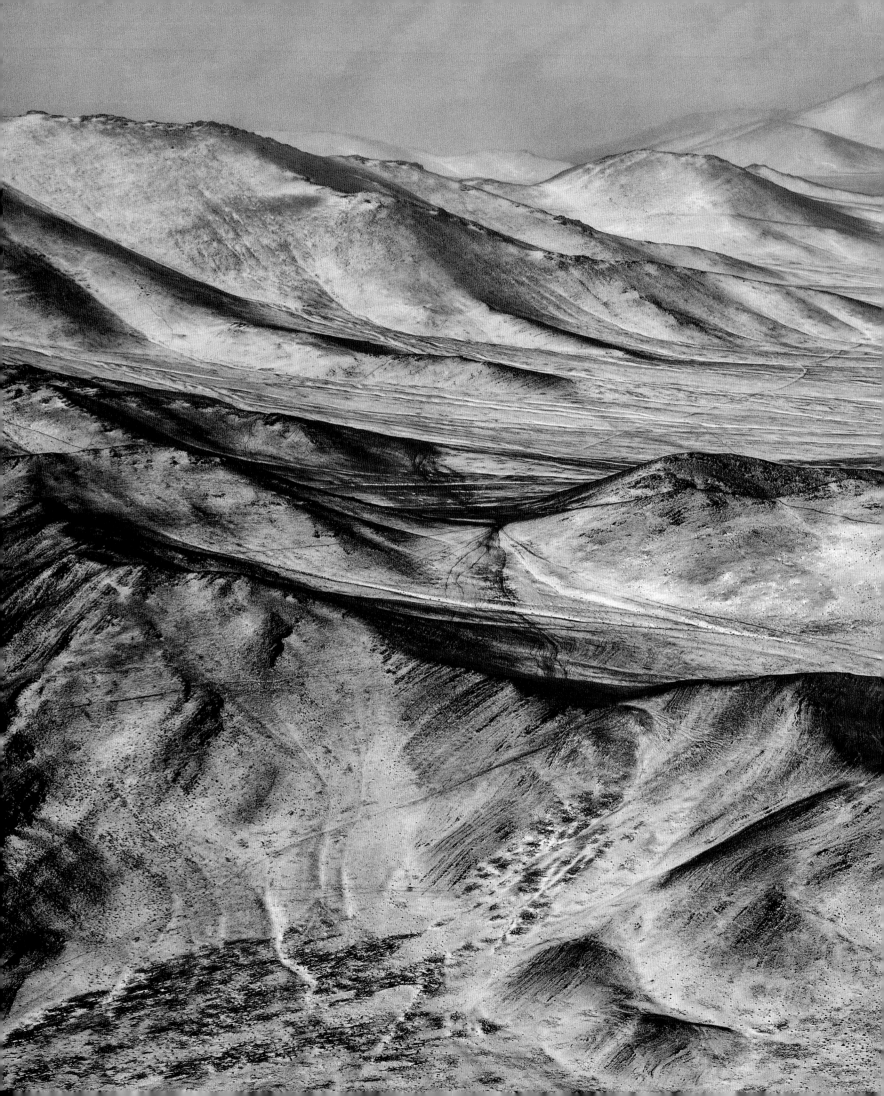

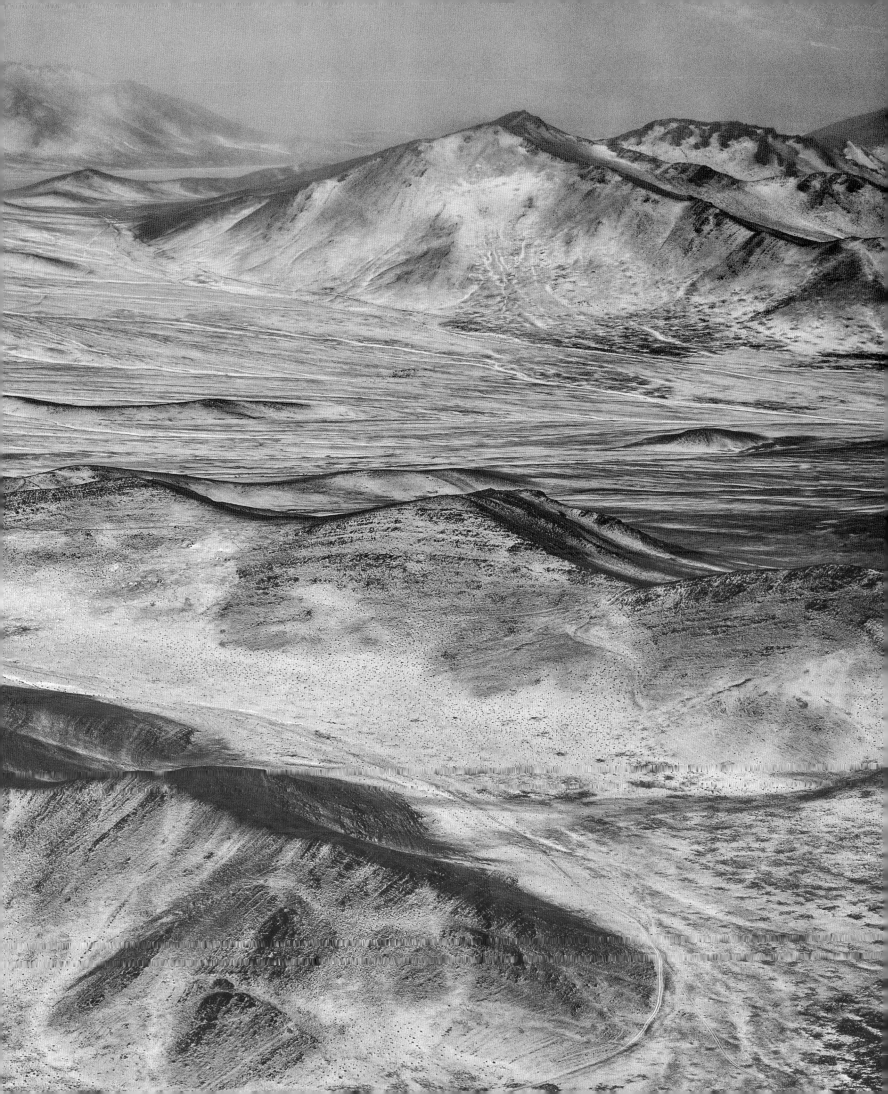

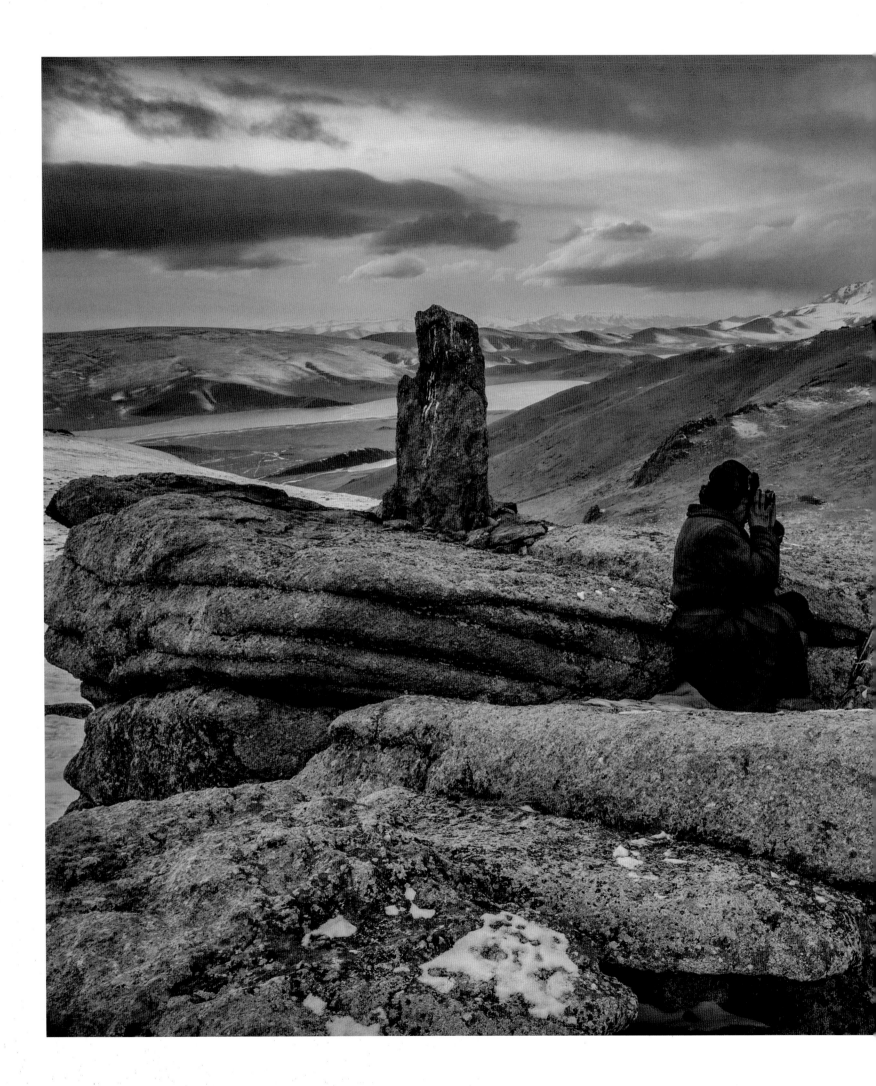

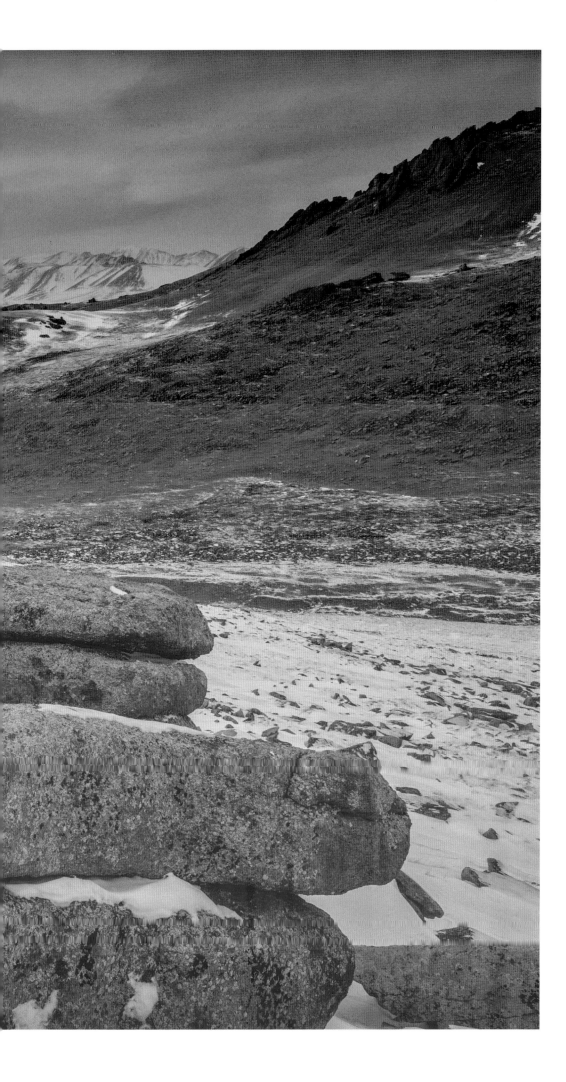

High on a mountain pass, a hunter sits patiently, scanning the horizon for a wolf or fox.

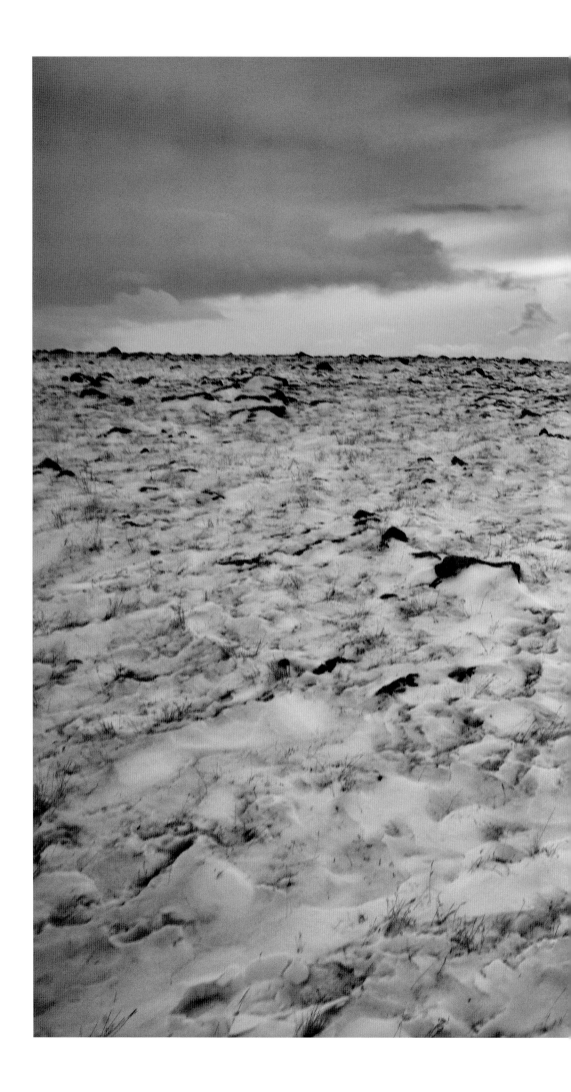

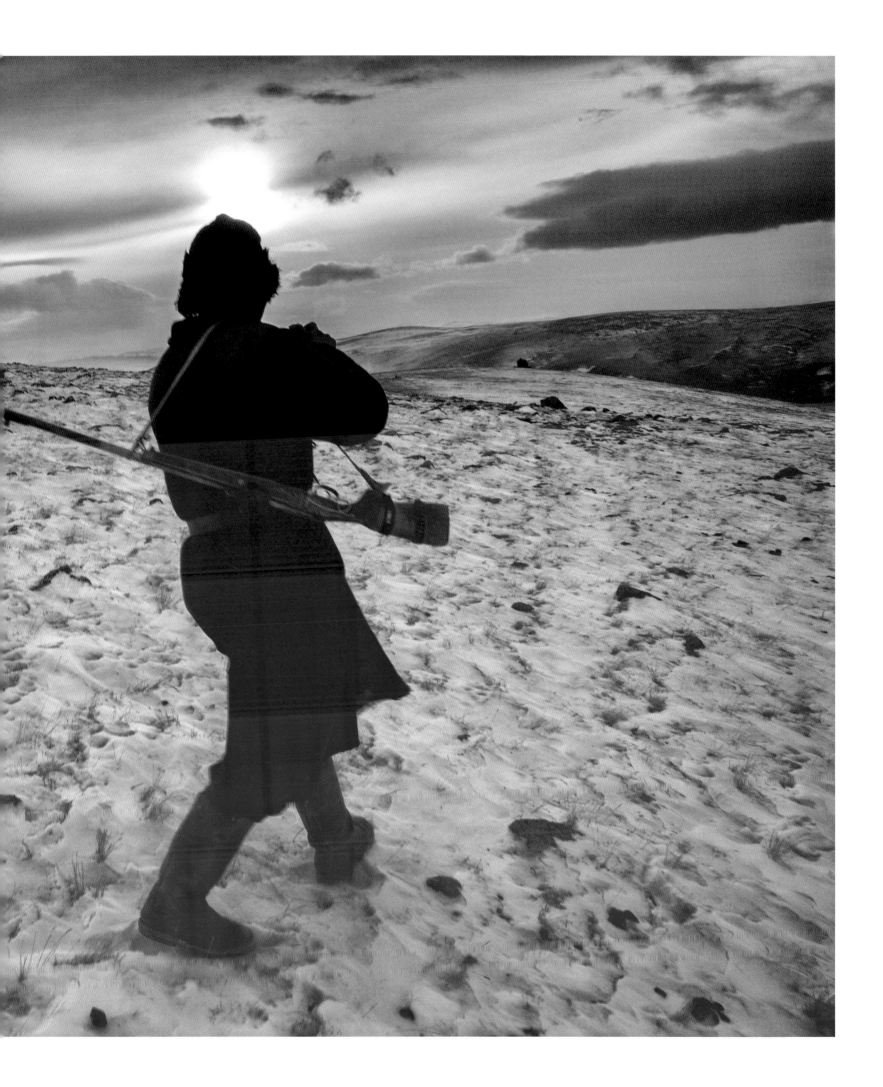

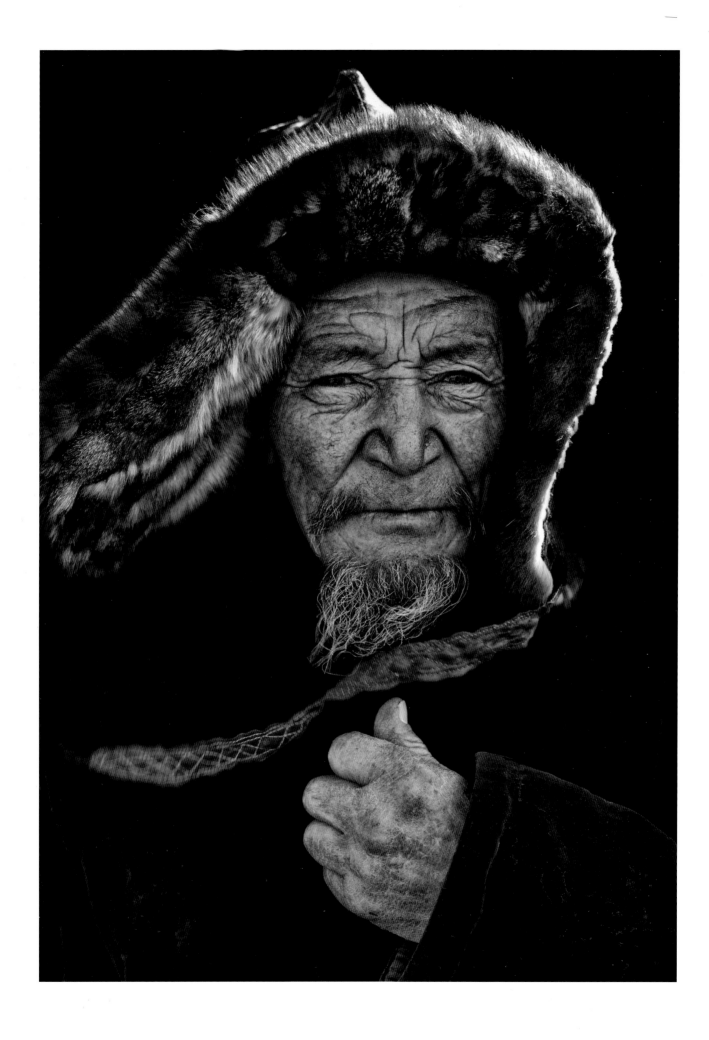

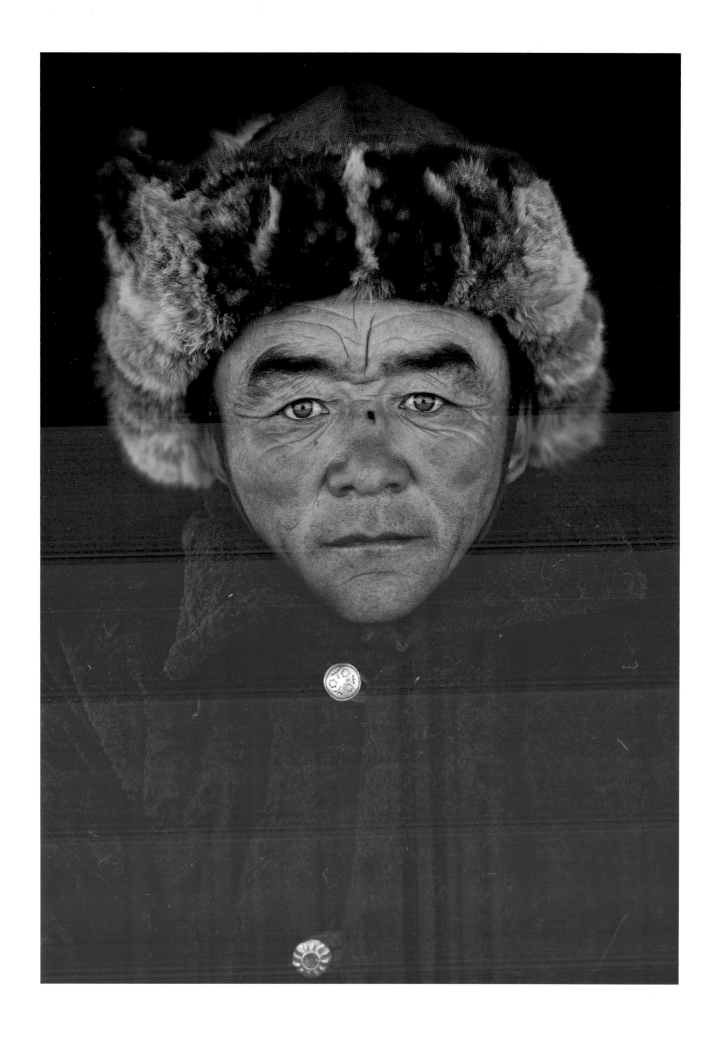

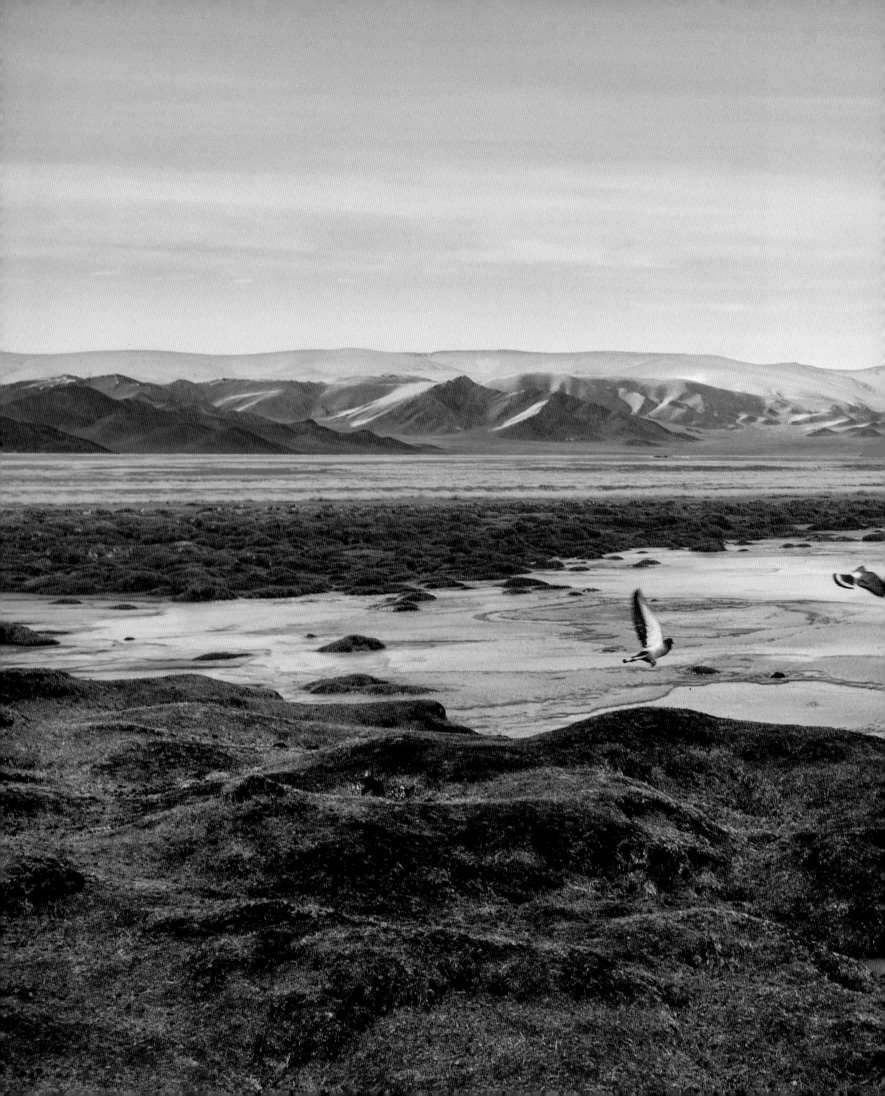

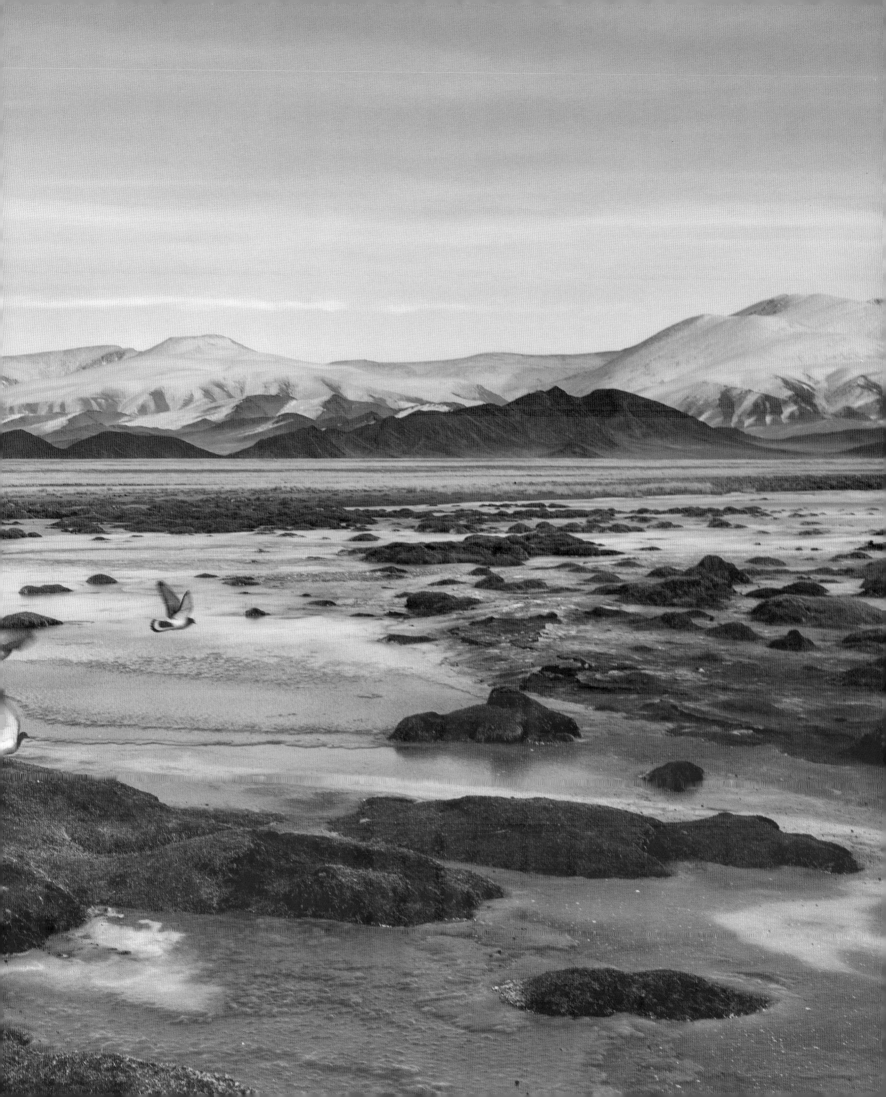

These spectacular lenticular
clouds are quite common in
western Mongolia, forming at
high altitude as the wind rises
over the mountains.

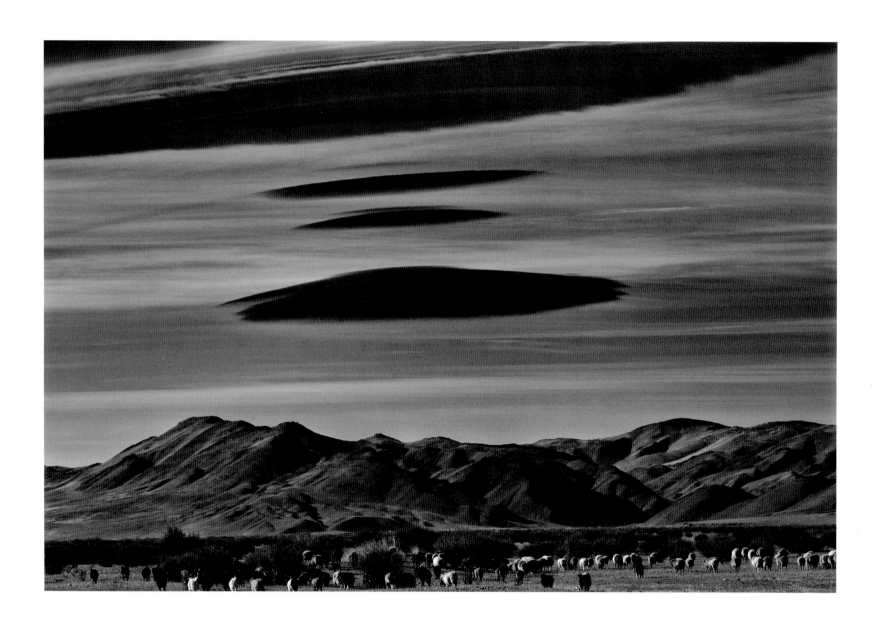

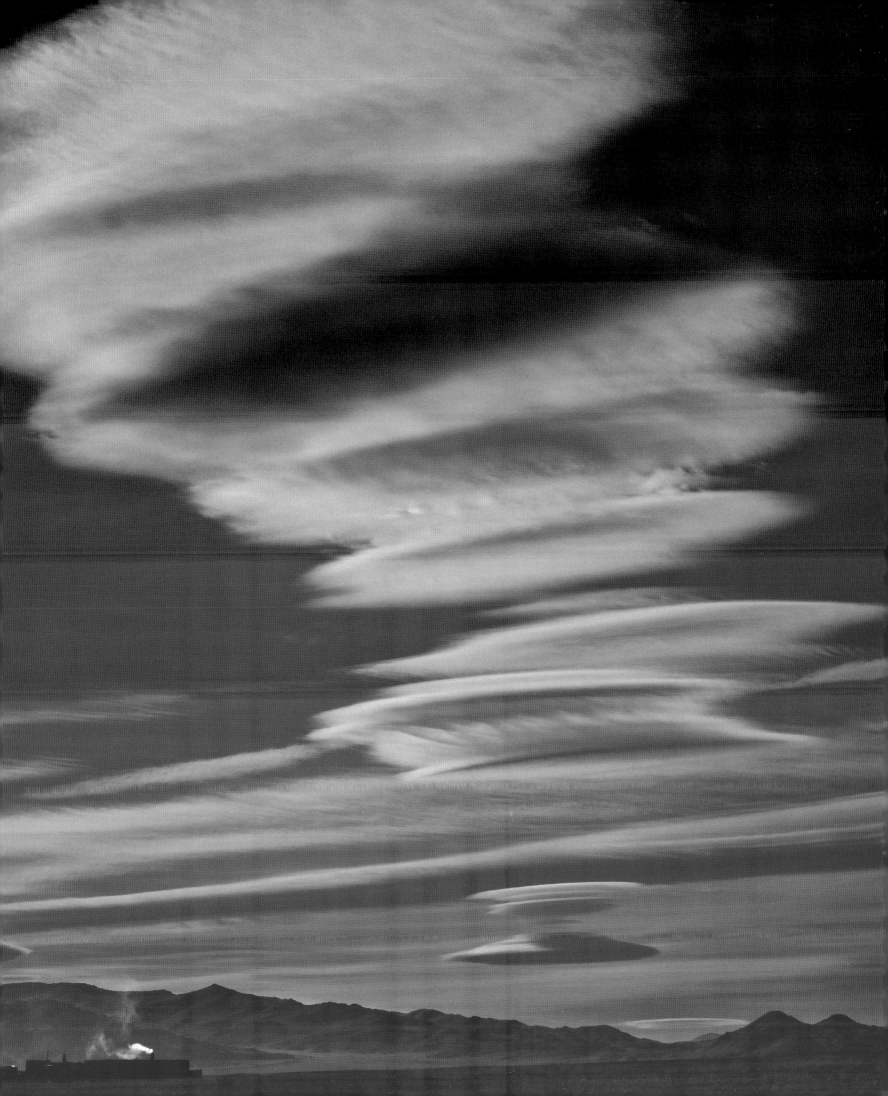

Acknowledgements

This book is dedicated to the people I met in western Mongolia during the four years
I worked on this project. Some I stayed with and returned to each year; others I spent
just a few minutes with on my journey. Their greeting was always the same: a smile and a
bruising handshake that seemed to go on forever. The hunters are getting old and the eagles
fewer in number. I'm grateful and immensely privileged to have met them and entered their
astonishingly beautiful world.

palanimohan.com

First published 2015 by Merrell Publishers,
London and New York

Merrell Publishers Limited
70 Cowcross Street
London EC1M 6EJ
merrellpublishers.com

Photographs, Introduction and captions copyright
© 2015 Palani Mohan
Foreword, design and layout copyright © 2015
Merrell Publishers Limited

All rights reserved. No part of this publication may be
reproduced, stored in a retrieval system or transmitted,
in any form or by any means, electronic, mechanical,
photocopying, recording or otherwise, without the
prior written permission of the publisher.

British Library Cataloguing in Publication Data.
A catalogue record for this book is available from
the British Library.

ISBN 978-1-8589-4643-6

Produced by Merrell Publishers Limited
Designed by Nicola Bailey
Project-managed by Claire Chandler

Printed and bound in China

Opposite:
At work with a family outside their home. The howling
wind usually caused havoc with the backgrounds that
I carried to Mongolia, but this was a calm morning,
and I spent some time making this image. It always
struck me how relaxed and proud these families were
in front of the camera.

Jacket, front:
Aibek Mana stands on the edge of a cliff with his eagle
on his arm, encouraging the bird to swoop on the prey
below; see p. 18.

Jacket, back:
A fox-skin coat keeps a hunter warm as man and bird
look out across the mountains; see p. 23.

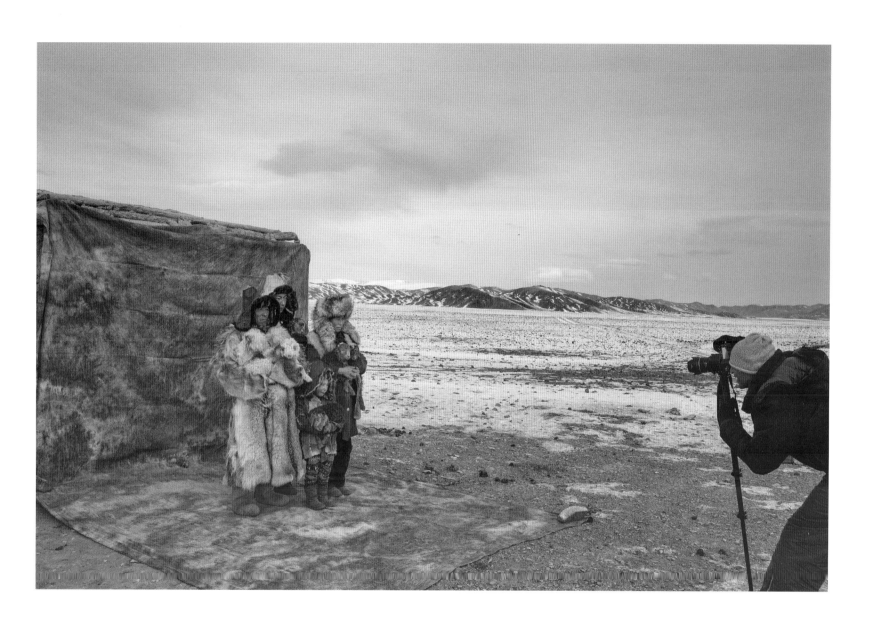

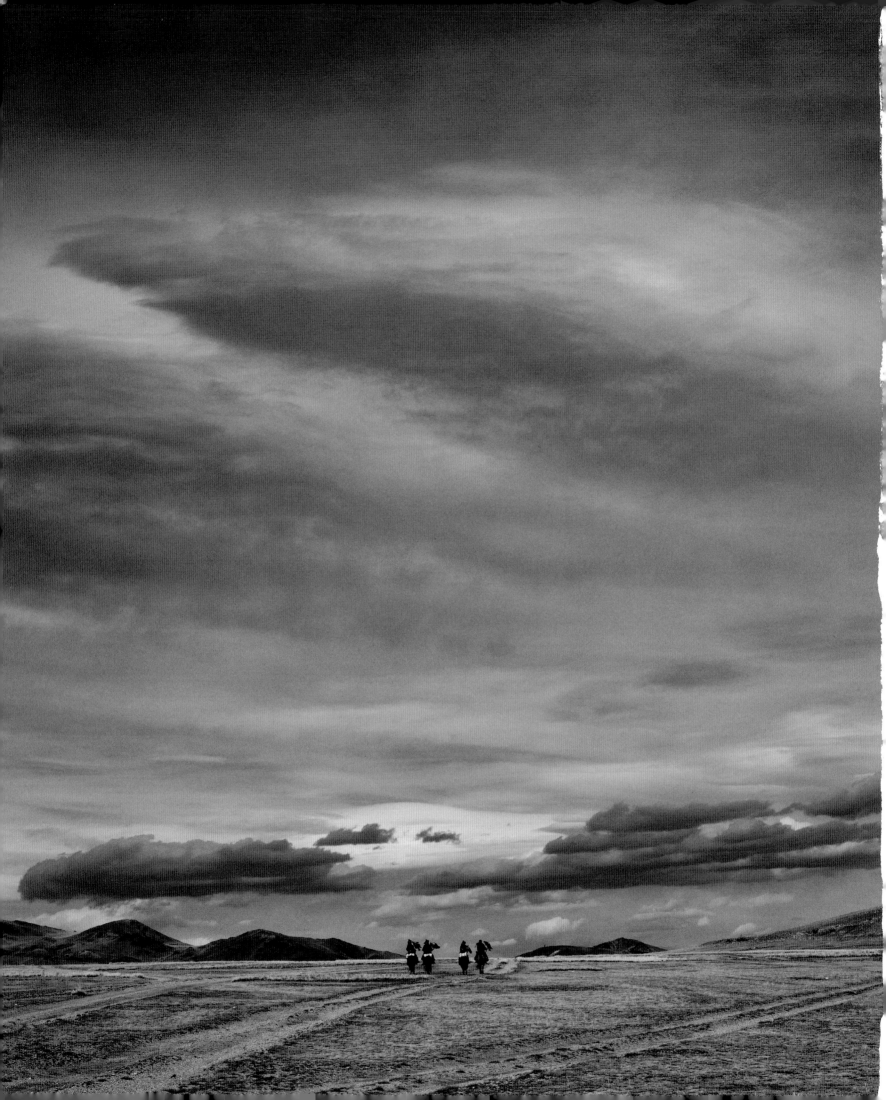